need to know?

Digital
Video

Colin Barrett

Collins

First published in 2006 by Collins
an imprint of
HarperCollins Publishers
77–85 Fulham Palace Road
London W6 8JB

www.collins.co.uk

Collins is a registered trademark of
HarperCollins Publishers Limited

10 09 08 07 06
6 5 4 3 2 1

Text © Colin Barrett, 2006
Design © HarperCollins, 2006
Photographs © please see acknowledgements

Created by **Focus Publishing**, Sevenoaks, Kent
Project editor: Guy Croton
Editor: Vanessa Townsend
Designer: David Etherington
Series design: Mark Thomson
Front cover photograph: ImageSource/Alamy
Back cover photographs: Colin Barrett/Pinnacle
Systems Inc/Canon (UK) Ltd

ISBN-13: 978 0 00 722961 1
ISBN-10: 0 00 722961 5

Colour reproduction by Colourscan, Singapore
Printed and bound by Printing Express Ltd,
Hong Kong

Contents

Introduction 6

1 **Formats and features** 8
2 **Making your first movie** 30
3 **Basic shooting techniques** 68
4 **Editing home movies** 120
5 **Showing and sharing movies** 166

Glossary 186
Need to know more? 188
Index 190

Introduction

Thanks to the digital video revolution, there's never been a better time to start shooting, editing and sharing your video movies with your family, friends and colleagues – but there are a few things you need to know before taking the plunge.

Buying your first camcorder

The decision to buy your first camcorder often follows the booking of a family holiday or an imminent addition to the family. It wasn't that long ago that the purchase of a decent digital camcorder with a generous range of features and specifications would have involved a significant investment, but these days the cost of a good, fully-featured, digital camcorder is a fraction of what it was only three or four years previously.

Not that long ago, home video movies recorded on camcorders would be enthusiastically viewed on the nearest TV – the funny bits replayed several times for the amusement of the kids – and then the tape would be packed away and forgotten about. The more savvy users might hook up the camcorder to a VHS recorder to make a copy or two for family and friends, but for most people even this was too much effort. Today, thanks to the availability of low cost, high performance, video editing systems using everyday computers, it is possible not only to edit your home video projects like a professional but also to create great looking DVD disks to send to family, friends and colleagues.

The fact that many of us use computers at work and at home means that we now have the tools at our disposal to make very acceptable digital video movies. Each day brings with it further technological innovation; camcorders are packed with more and more features and produce images and sound with staggeringly good quality at equally shocking low prices, and the average home Windows PC or Apple Mac computer is often more than

sufficient to import the footage from the camcorder, chop out the unwanted bits, add titles and music before dumping the whole thing out to a DVD disk for sharing. What's more, the rapid take-up of broadband internet means that it is a simple job to add your video clips to a website, email them to friends or send them direct to people's mobile phones, PDAs or iPods.

Perhaps the most significant thing about digital video is that it is helping to sweep aside the mystique of film-making. Whilst it is true that there are certain unwritten rules on exactly how to produce movies that will grab the attention of your audience, it is also the case that a home movie that looks good and sounds great can be produced with virtually any digital camcorder and an everyday computer. Even the software programs required to edit your video footage and make DVDs needn't cost you anything. With the technology at your disposal, all that is really required is your willingness to have a go.

The future is here, and the fact that you are reading this book means that you have a desire to become part of it! Enjoy.

Advances in digital video mean that anyone can make high quality films.

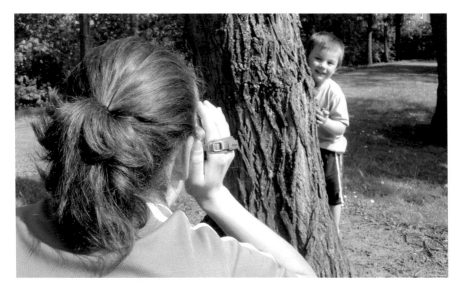

1 Formats and features

Before you reach the stage where you can make your first video recordings, you need to decide what medium your recordings will use. For years, tape cassettes have been the only viable video recording medium, but they now face serious challengers in the form of DVD and solid state media cards as the format of choice for many newcomers. So what's best for you?

What is digital?

We're living in a digital world. Sales of VHS video players have plummeted in favour of recordable DVDs and hard disk systems, and a new camcorder is almost certain to be a digital model.

Leaving analogue behind

In the good old days of VHS or Betamax video, vinyl LP records and audio cassettes, we recorded and replayed our TV shows, taped the kids playing in the garden and listened to our favourite music without the help of digital technology. All these systems used analogue processing, which was fine in its day, but technology has moved on. The audio CD introduced us to the benefits of digital signal processing and we have never looked back.

The trouble with analogue recording systems is that when the billions of magnetic particles on a tape are arranged according to the frequencies applied to them, which, in turn, relate directly to the electrical signals being fed to the recording head, it is very easy to mix up the signal you wish to retain with all the other stuff that gets in the way – such as the natural hiss that a tape makes when it plays. When you play one back, you inevitably get the other as well. Look closely at your old photos or listen to vinyl LPs and you will see grain and hear rumble and hiss respectively. That's what you get with analogue.

Bits and bytes

Where digital has the advantage, however, is that it deals not with sound or light waves that can vary according to a range of local conditions, but with a

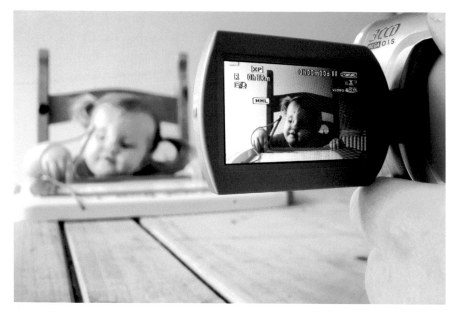

Children are surrounded by technology in their lives and will soon become very comfortable being the subject of any movie.

highly-complex sequence of ones and zeroes – in other words, binary code sequences. The mathematicians among you will know that a binary sequence is made up of a combination of the digits 1 and 0, where '1' is 'on' and '0' is 'off'. It's either positive or negative, it exists or it doesn't exist, quite simply. This lack of a mathematical 'grey area' means that once a piece of sound or an image is interpreted as a long string of binary numbers, that's how it stays. This is very handy, because it now means that when you make a digital copy of a tape, either from camcorder to camcorder or camcorder to computer, you are effectively making an identical clone; however, if you have ever made a VHS to VHS tape copy you will know that the loss of picture and sound quality is considerable. That's why, for video enthusiasts, digital is better.

Working in the digital domain

One of the main reasons why it's a good idea to go for the digital option is that it is neither economically beneficial nor practical to go down the analogue route any more. Not only that, but it's increasingly difficult to acquire Hi8 and S-VHS camcorders anyway; they are simply not being made in any significant numbers any longer. From a cost point of view, there is little to be saved by not buying a digital camcorder – the cheapest ones are no more expensive than their analogue counterparts.

In general, you will find that you will have a lot more scope with a digital camcorder. Given that we are handling great long strings of ones and zeroes when making a recording to either tape or disk, it's a simple job to copy data (for that's what your camcorder recordings become) from the camcorder to a computer or even to another digital camcorder. What is even better is that it all takes place 'losslessly' – this means the bits and bytes move around without loss of data or quality. That's more than can be said of the same clips recorded in an analogue camcorder.

Movies and stills in one device

The one thing that many users find immensely useful about the newer generation of video camcorders is that they afford an opportunity to shoot not just video but also digital stills pictures. Lots of today's camcorders possess not just a tape (or disk, depending on the format used) but also a slot for a flash memory card designed to store the photos you take. These use the same type of cards that you will find in a typical stills camera – Sony

MicroDrives and internal Hard Disk Drives as used in some current tapeless camcorders are tiny, as this picture shows.

Just as analogue gave way to digital, videotape is rapidly conceding ground to solid-state memory cards that facilitate high-quality video recording.

Memory Stick and Memory Stick DUO, MMC (MultiMedia Cards) and the increasingly popular SD (Secure Digital) and Mini SD cards. What's more, it's likely that you'll be able to copy still images to your recorded video clips and capture still frames from video and save them to the card, after which they can be imported to your computer using the USB cable that comes with virtually all digital camcorders.

Getting connected

An additional advantage of digital camcorders is that you have the opportunity of copying your collection of clips from the camcorder to either a Windows PC or Apple Mac computer using very simple and trouble-free connections in a lossless manner – that is, no loss to recorded data at all. For digital camcorders that record to tape – such as Mini DV and Digital8 – the best way to transfer your recordings is by a connection system known as FireWire. This entails using a single cable to transfer video, stereo sound and all the other data that's embedded into the data. It also allows you to forget about the camcorder and control its functions remotely from the computer. FireWire is also known as i.Link, and its proper description is 'IEEE1394 standard connectivity'. Other tapeless video formats depend upon USB 2.0 for file transfer connections to be made.

must know

The Charge Coupled Device is the part of the camcorder that converts light into electrical impulses from which the digital data is derived. One CCD has to create the whole image, whereas each of three CCDs can process red, green and blue separately. Three CCDs are usually better than one!

Digital recording formats

If you are a first-time camcorder buyer you'll be faced not only with the choice of which camcorder suits you but also with the problem of deciding in which format to make your recordings.

Increase in choice

Not long ago, the choice was limited to either DV (also called Mini DV) and Digital8. Both use tape cassettes to store the digital video recordings. However, these days, the choice also includes SD cards (similar to memory cards used in digital stills cameras), hard disk drives and removeable MicroDrives. In addition to all of these is perhaps the biggest challenger yet to DV tape, namely recordable DVD.

Recording on tape

Despite the rise in popularity of the competing formats, the medium that will provide you with the best quality and most reliable recordings is DV tape. Why? Well, although the data stream employed by DV relies on a degree of video and audio compression to pack the data onto the limited surface of the tape in the cassette, it's still the better option compared to the level of compression that's required to pack all the relevant information onto a DVD disk, SD video card or HDD (Hard Disk Drive) camera. All these recordings require the recording information to be compacted very heavily, using a compression system called MPEG2. All set-top DVD players use the same method of compression to cram lots of data into a small space. Whilst the reproduction is undoubtedly good in a general sense, it's not as good as DV.

Digital8

You may encounter another tape format called Digital8 as you research recording formats. Sony introduced this format as a means of extending the use of its Video8 and Hi8 tape formats, but although these were analogue tape formats, all camcorders in the Digital8 range record the same type of digital video stream as used in DV. The only difference is the tape itself. Early in the life of the format, it was possible to play your analogue 8mm tapes in a Digital8 camcorder, and even copy them digitally. However, with the format now in its final lease of life, the ability to do this is limited. For new users, it's not worth considering Digital8 at all.

Camcorders that don't use tapes

As an alternative to recording on digital tape, an increasing number of camcorders now enable recording direct to DVD disks, solid-state media cards and also tiny built-in HDDs. We refer to these as 'tapeless' camcorders. Although the recording

Many people like the ease and convenience of a DVD camcorder, which allows you to remove the disk and play it directly onto your TV.

media employed does vary, the system of video and audio compression employed to squeeze all the information into a small space is the same – MPEG2.

DVD

There is a large choice in camcorders that record to DVD disks, bringing with them the opportunity to remove the disk from the camcorder and view its contents on your TV using your standalone set-top DVD player or recorder. The 8cm disks used by DVD camcorders are 2cm in diameter smaller than the standard DVD disks. They can be played in DVD players, but are currently less easy or cheap to obtain than DV or Digital8 tapes. However, their ability to offer you an instant access to recorded clips via a menu system makes them as easy to use as a digital stills camera, and for that reason they will continue to be attractive to many first-time users looking for a quick and easy solution to their home video needs.

Remember that there are two main types of recordable DVD disk. A DVD-R disk will enable you to record once only, with no facility to erase the recording and make new ones. DVD-RW, on the other hand, is a re-writable format which allows you to delete all the clips and use it again. RW disks are more expensive to buy but will save you money in the long term. You will need to copy your clips to computer or DVD recorder before erasing, of course!

Hard Disk Drives and MicroDrive cameras

You might also consider the convenience afforded by an increasing range of so-called Digital Media Cameras that record not to tape or removable disks but to tiny internal HDDs not dissimilar to those

must know

Managing video clips stored on DVD, HDD and SD cardcams is as easy as it is with a simple digital stills camera. Simply select the thumbnail image and click to delete it. You can also set up a playlist in order to view sequences on TV in your preferred order.

used in Apple's range of iPods, as well as in other portable media playing devices such as the Sony Playstation Portable (PSP). JVC's Everio HDD cameras offer up to 7 hours of DVD-quality video recording on the HDDs of some of its models in the range when using the highest quality setting. If you are happy with lower quality, you can squeeze up to 37 hours' recording onto the disk. MicroDrives, on the other hand, are small removable disk drive media that allow up to 4GB (GigaBytes – or thousands of millions of bytes of information) onto one drive. This is only slightly less than the capacity of a standard DVD disk at 4.7GB. MicroDrives perform in much the same way as HDDs except that they can be removed once full and replaced by an empty disk. However, they're very expensive to buy, so you might consider the HDD option instead.

SD-Video Cardcams

MMC (Multi Media Cards) or SD (Secure Digital) cards are used in digital stills cameras to store your digital pictures. With SD cards it's possible to use them in video cameras and camcorders too (though check first to ensure that they can handle the increased data rate required). SD-Video cards enable the saving and replay of compressed digital video clips using the DVD-compatible MPEG2 video compression system. As the capacity and data transfer speed capabilities of SD card technology improves, this is likely to replace tape as a means of recording home video altogether. SD gives you the added advantage of size; the SD (and particularly Mini SD) cards have the advantage of being tiny, which in turn enables the manufacturers to come up with ever smaller camcorders.

watch out!

Sony's MICROMV is a tape-based format and records a compressed video signal like DVD, but although it uses FireWire for transfer there are few systems that can make use of it. It's effectively an obsolete format, so avoid the temptation to buy such a model, even if it's cheap!

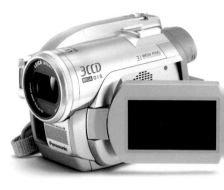

An increasing number of DVD camcorders are capable of recording in widescreen.

What do you want it for?

How much you have to spend on a camcorder is an important consideration in deciding on the model that will suit you, but your choice of model must also be determined by the likely use to which your new purchase will be put.

Family clips or work-related?

Whether you aim to use a camcorder as a way of documenting special family events or for more specialized purposes, consider what you want to do with it before beginning your search. For instance, if you're intending only to shoot video clips while on holiday or at family parties, then a low-cost, modestly-featured camcorder will probably be sufficient. However, if you intend to offer video recording services to others then you will require a model that is more sophisticated. In all cases, budget is – of course – an all-important factor in determining what we can and cannot acquire.

Casual home movies

If you just want to grab shots of the children splashing around in a holiday hotel pool, then consider a camcorder that enables you to record and replay decent quality footage with ease. Many DV and Digital8 camcorders have a DV-in facility – which means it can be used as a digital recorder as well as a camcorder, enabling you to make a clone copy from one camcorder to another or from your editing computer. Most home users need a camcorder that is easy to use, has a good zoom lens and – increasingly – can take digital stills images as well as video. The ability to connect the camcorder to a TV set, VHS video or DVD recorder is also a must.

Serious and semi-pro uses

It could be that in addition to shooting home movies you'll want to earn some extra income by recording events for financial reward.

Thanks to the superior quality afforded by modern equipment it's quite common for relative beginners to record community events, school or church performances or even wedding day celebrations for paying or non-paying clients. If this is something you are considering, then look further up the features scale with a 3CCD camcorder that provides for the input of an external microphone, headphones and lighting accessories. Greater manual control over the camcorder's operational functions, as well as the ability to input a wide variety of video sources, might also be useful.

Recording from other video sources

Some find it useful to be able to copy older analogue recordings from VHS, Video8 or Hi8 tape onto either tape or disc in a digital camcorder. Lots of camcorders have what's called 'AV-in' – the means to connect up video and audio cables from a player or camcorder and re-record the sequences digitally in the camcorder. In some cases it's possible to pass the straight through to your computer via a special digital cable connection called FireWire without first recording in the camcorder.

Consider carefully what you will use your camera for. There is no point in lavishing funds on equipment that will mainly be used for holiday videos.

Useful features to consider

Believe it or not, many digital camcorders have much in common with others despite differences in their appearance and specifications. Having decided what you wish to do with your camcorder it is important not to be swayed by enthusiastic salespeople. Make an informed choice and then stick to it.

Shopping around

The majority of you will be attracted to a particular model by its appearance. This isn't surprising; all electronics devices are designed to have immediate visual appeal, so it's quite reasonable that they should be made to look good. When shopping for camcorders it's really important to try and handle a few models. Only by picking up a range of models can you get a feel for what suits you and your potential uses. Shopping online is one way of making your choice, but images don't necessarily convey an accurate impression of the size, general handling or weight of a given model. Some camcorders, for instance, are designed for people with smaller hands and you might find the buttons or switches impossibly small and inaccessible.

Basic essentials

One thing's for sure – every camcorder has to have a lens, a microphone, a means to view what you're shooting and quick, easy access to the essential record and replay controls. In the case of some simple point 'n shoot models, that's pretty much all they do have. However, it's unlikely that you'll be content with such simplicity for long, so it's

Features checklist

Consider these factors first when checking out a given model:

- Good sized CCD – 0.4cm (⅛in) or above
- 3CCDs if possible!
- Zoom lens ratio – 10x or above
- Large LCD screen – 9cm (3.5in) preferably
- Top-side tape loading bay (if appropriate)
- Digital and analogue inputs/outputs
- Good manual controls
- Headphone output socket
- Additional microphone input socket
- Easy menu system
- Memory card for still photos
- Image stabilization

important that you choose wisely. Whether a camcorder uses tape, disk or card as its primary recording medium is another matter, but in the first instance you will need to consider the basics.

Features to look for

First thing to check is the size of the camcorder's flip-out LCD screen. Lower-priced models tend to offer only 6.5cm (2.5in) screens, which won't be a problem if the menu system they display (in addition to the video and stills images, of course) is clear and easily navigable. Higher-priced models will often give you a larger LCD screen, and you will find this very useful once you get used to using the camcorder. Secondly, consider the camcorder's optical zoom lens – this is what enables you to 'zoom in' to distant objects without physically moving. A zoom magnification of 10:1 gives you the ability to achieve a 10x magnification. Some camcorders offer 12x, and it is not uncommon to see 14x on newer models. This is desirable.

Also of great benefit to you will be to have a reasonable chance to control aspects of the camcorder's operation manually – such as focus, aperture (the opening and closing of the lens to let more or less light in) and white balance (the colour of light that varies from outside to inside the home). It's also very useful to be able to re-record video sequences onto digital tape in the camcorder, and for that reason check whether a camcorder has DV and AV inputs. We will discuss this in more detail in later sections. For other useful features worth checking at the time of purchase, see the Features checklist box on the opposite page.

watch out!

Don't be persuaded by very high zoom factors, such as 800x or more, when looking at camcorders. Digital zooms corrupt the data within an image for the sake of magnification and should be ignored. Look for a good optical zoom ratio – such as 20x – instead.

What the brochures don't tell you

One thing you will discover about digital camcorders and all of its associated technology is that things are not always as complicated as the manufacturers and marketers would often like you to believe. Be wary of the sales pitch!

Don't believe the hype

Here are a few examples of features that are promoted as being worthy of your hard-earned cash but are, in reality, of little use.

Digital zooms

In contrast to the optical zoom that most cameras and camcorders possess, a digital zoom uses electronic rather than optical means to achieve a higher magnification factor. The pixels are bigger, but as the magnification ratio increases to values of 800x, the picture is rendered useless.

Zoom microphones

As you zoom into a subject visually, the sound being captured by the microphone is intended to mimic the action. The zoom effect can be noticeable in situations where audio is clear and distinct, but in general they tend not to produce the desired effect on playback.

Creating movie titles in the camcorder

The camcorder's menu system will provide you with the opportunity to create fancy titles which are then inserted onto the video footage as it's recorded. However, the increasing use of computer-based editing packages renders this whole process unnecessary.

must know

It's natural for you to assume that the supplied USB cable is all you need to transfer your full-specification movie recordings to computer prior to editing and DVD creation. Unfortunately, this isn't always true. The best option is to transfer DV or Digital8 digital video tape footage using FireWire – also known as i.Link. This isn't the case with DVD, SD cardcams or HDD cams, however, because the recordings are already compressed and for which USB 2.0 is adequate.

Widescreen – is it true?

The most common form of widescreen found on low-cost camcorders isn't really widescreen at all – the regular image has had its top and bottom shaved off to give a letterbox 'cinema' effect which, when viewed on a widescreen TV screen, will reflect a lower resolution picture than if it had been left alone.

Megapixel picture quality

Some camcorders are promoted as having picture resolutions measured in terms of megapixels (millions of pixels), but what they often don't tell you is that the CCD that creates the images for video can't really use more pixels than are standard for your TV system. Although manufacturers sometimes make additional pixels available for additional movie functions such as Electronic Image Stabilisation, those camcorders that offer a high number of pixels devote them to digital stills images which are saved to memory card.

Digital zooms electronically magnify the *pixels* (picture cells) making up the image. Most digital zooms used at full magnification of 120x or more will impair the quality of your footage, so treat them with caution.

How will your footage be used?

Having recorded their video footage to tape or disk, a great many home video makers still rely on showing all their footage to family and friends in its raw form rather than attempting to even chop out the unwanted bits. Is that really the way you want to share your home movies with your loved ones?

must know

FireWire (also known as i.Link and IEEE1394) is the key to good quality digital transfer of tape-based formats into a computer for editing. A single FireWire cable gives the computer complete control over the camcorder's playback and record functions in addition to carrying the signals back and forth. It's the standard means by which we transfer digital video tape sequences between computers and other camcorders or recorders.

Editing highlights

Taking the trouble to record a lot of interesting footage of your latest holiday vacation or school sporting event and then expecting your viewers to sit through two hours of unedited footage is a bit like showing people the holiday snaps in which your finger blocked the lens. Wouldn't it be better to tidy up the material first by chopping out the unwanted bits before showing it?

Options for sharing

Not long ago, your only option for sharing your videotaped memories with others meant either showing the original tapes or making a rather crudely-edited VHS copy, adding simple titles and credits to the beginning and end, and maybe a commentary. Thanks to low cost computer hardware and software it's now easy to create a professional-looking video.

The right tools for the job

If you're keen on sport, for instance, and you wish to distribute DVD copies of sporting events to members of a club or society, you might need a camcorder with good optical features and manual controls. It could also mean that you will require additional recording facilities such as a good directional microphone and monitoring

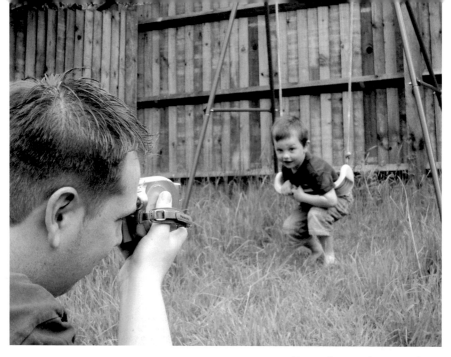

headphones. If that's the case, it is essential that your camcorder has the appropriate sockets to accept the mic input and headphone output.

Recording direct to DVD

Most of us view commercial movies on DVD, so it's natural that we should seek to produce our own movie projects on DVD. However, if you're thinking of doing accurate editing, think twice about recording direct to DVD. Consider a tape format instead.

Creating email or web-cam movies

It's possible to turn selected sequences into smaller, compressed video clips that can be sent to others as email attachments. Camcorders that use memory cards to store digital stills pictures usually have the means to record MPEG4 'email movie' clips direct to the card prior to transfer to a computer via the USB cable or even use your camcorder as a web-cam.

Taking the tapeless route

Despite some drawbacks to shooting on formats that don't use tape, lots of people new to home movie-making are opting to make DVD, HDD and Cardcam recordings instead of digital tape. They all have the advantage of simplifying the video-making process, but such new technology comes at a price.

Avoiding tape

In previous sections you will have read how it is now possible to avoid recording to tape altogether, and that in many cases this makes not only the management of clips within the camcorder a lot easier but it also opens up new opportunities for transferring your recordings to other devices without requiring a great deal of technical know-how.

Random access

Unlike tape, where it is necessary to spool the tape forwards or backwards to the correct point (if you know it), a disk or solid-state camcorder will allow you to click on the clip you wish to view to play it instantly, and offers you the same random access to files as when opening files on a computer. The principle is exactly the same; these digital video clips are just computer files after all, and can be deleted, moved or modified accordingly.

Quality issues

Opting for a camcorder that does not record to tape is very tempting for many home users, but there are some additional issues to consider. Whilst there's the undoubted convenience of being able to copy your clips digitally into a computer or home recording system much more quickly than if you had to wait for a DV tape to transfer in 'real time', you won't get quite the same visual quality as if you were recording to digital video tape. As

most tapeless systems save files in the compressed MPEG2 format, you will need to think carefully about whether you wish to undertake any detailed editing of your sequences before making finished DVDs to send to others. Depending upon which camcorder you use and which piece of editing software is provided with the product, it could be that the process of creating a DVD will involve re-compressing the already compressed DVD sequences prior to writing them to the blank DVD disk. This could affect the final image quality.

HDD and SD Cardcams

Recording with an HDD (Hard Disk Drive) camcorder or a so-called Cardcam that uses solid-state memory cards will also have major advantages; in the case of HDD cams you will benefit from a very large amount of internal hard disk drive space which has the potential to accommodate the several hours of footage you might shoot on vacation. It does, of course, depend upon compression. By using the highest quality setting on the recording, you will use up more space on the available storage media (the disk or card), and this will reduce the amount of material you can store. An HDD camcorder has a fixed, built-in drive which cannot be supplemented or changed and though it's perfectly possible for you to obtain additional media cards, such as SD-Video cards, they are very expensive.

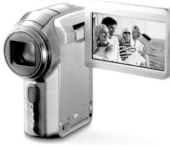

Pocket-sized digital media cameras that record DVD-quality video to tiny SD cards are spearheading the next phase of home video.

Availability of media when away from home

Another thing to think about is the availability of additional recording media when you are away from home and running out of tapes or disks. If you are a user of a DV or Digital8 camcorder, you will have no problem obtaining blank tapes in any major town, city or popular tourist destination. At the moment, the same cannot be said of the special 8cm DVD rewritable disks required by DVD camcorders, nor the high-capacity SD-Video cards being used increasingly by solid-state camcorders.

Using a computer

With blank DVD recording media now cheaper and more accessible than ever before, it is natural that an increasing number of camcorder users should seek to create DVD copies as a way of sharing their home videos with others. For this, you need a computer in order to copy and 'burn' digital files.

must know

There are two types of FireWire connector. The smaller 4-pin type is what you'll find on every DV, Digital8 and HDV camcorder, whereas the larger 6-pin 'powered' type will usually be found on the computer itself, and also on external storage drives. Check what connections you need carefully before buying.

Share your movies

Whether you are recording onto tape, disk or solid-state memory card, there will undoubtedly come a time when you wish to distribute copies of your home video efforts to relatives and friends, either on one of the main disk formats or as an email attachment in the form of a 'web movie'. Many homes now have computers that are capable of importing and processing the digital signals that are stored on camcorder tapes, disks and cards, so why not use them to creative effect?

Windows PC or Apple Mac?

It's very likely that your computer runs a Microsoft Windows operating system, such as XP Home. Windows PCs account for the majority of personal computer sales all around the world, and for this reason many camcorder and digital video applications companies produce software to run on Windows. However, Apple Mac computers have long been the established and favoured computer system for people working in the TV, film, design and publishing communities since the mid-1980s, and many Mac users will argue that it's the best operating platform for creative video applications, too.

Whatever your chosen computer platform, you can be sure that with the right hardware connections and computing resources you will have the means to import your clips from your camcorder or camera, edit them with a host of creative digital software tools and export them to a variety of formats according to your requirements.

Computer hardware requirements

Whether you decide to go down the Windows or the Mac computer route, you need to be aware of the minimum set of requirements needed in order to manipulate digital video efficiently. You may already have noticed that modern camcorders come supplied with a USB cable, and it's natural to assume this to be for the transfer of video signals to the computer. Whilst this is true for formats that don't use tape, it's still the case that DV and Digital-8 recordings require FireWire cabling when transferring to and from a computer that itself has a FireWire port. USB is appropriate mainly for digital stills and small compressed video transfer only.

want to know more?
• Read the monthly magazines and familiarize yourself with current models.
• Take time to compare prices online and with your local resellers.
• Try and handle a small selection of camcorders before committing to your first purchase and make sample recordings if possible.

weblinks
• Visit the Consumer Association's website for independent buying advice and test reports at www.which.net
• Visit the author's own website at www.simplydv.co.uk
• Visit the website of publications such as *Digital Video Techniques* at www.imagine-publishing.co.uk, in addition to both *Digital Video* and *What Digital Camcorder* magazines at www.futurenet.com

2 Making your first movie

Here's the best bit. You have your new camcorder and you can't wait to unpack the contents of the box and get started. It's quite natural that you should wish to insert a blank tape or disk and hit the record button without hesitation, but before you take a leap into the unknown, have a quick look at the following pages. There are a few things you need to know before you get going!

What's in the box?

You have bought your very first camcorder and you cannot wait to open its packaging in order to see what goodies are inside. This is the moment when you begin to discover what it can do – but take time to ensure that its contents are all in order first!

must know

All DV and Digital8 camcorders use FireWire (also known as i.Link) to transfer digital video from cam to computer. You'll need to buy a FireWire cable separately as they're never supplied with the camcorder. The supplied USB cable might not be appropriate for this job – so check first.

Checking the contents

Opening the box in which your brand new camcorder is packed is an undeniably exciting moment, not only because you get to handle the camcorder itself for the first time but also because you quickly discover how many other bits and pieces come with it. The first thing to look at is the User Guide. There's often a page – usually near the beginning – which itemizes the accessories that you will need to get started. It's important to check that you have everything; although manufacturers rarely omit to pack an item it does happen from time to time, and you will need to alert your reseller quickly if this is the case.

Is everything in the box that should be? Check off each item of kit very carefully against the inventory in the User Guide.

Standard accessories

Regardless of their recording format, all modern camcorders come with a standard set of components. To begin with, you will need to power the camcorder and so not only will a re-chargeable battery be supplied, which will usually give you anything from one to two hours recording and playback time, but the package should also come with the means to recharge it. An AC adaptor will supply mains power supply and also act as a battery charger. Some can charge the battery whilst on the camcorder, whereas others require the battery to be removed and slotted onto the charger itself.

Other standard accessories will include a lens cap, a Lithium button battery which should be inserted into the camera and which stores such essential electronic information as the current time and date.

Getting connected

To view your movie footage on a TV screen or even copy to a standalone recorder, such as a home VHS or DVD recorder, an AV connecting cable will be included. This often has a single small plug that connects with the camcorder which breaks out to several coloured video and sound plugs at the other end. Depending upon your camcorder, it might be possible for you to record video from a VCR or TV on tape or disc in the camcorder with this cable. Almost all camcorders will be supplied with a USB cable; usually, this is for transferring still pictures and compressed 'email'-type video clips to and from a Windows or Apple Mac computer, but it's increasingly used to transfer full-screen video, too. Lastly, a wireless remote controller will enable you to control the camcorder's playback and record functions just like a home video recorder or TV.

must know

In Europe, home audio-visual equipment – TVs, VCRs, digital TV receivers, DVD recorders – are supplied with SCART sockets as a means of easily connecting devices to each other. In Europe, all camcorder manufacturers include a one-way output SCART adaptor plug to make connection to TVs and recorders easy.

Features and functions

Most modern camcorders are designed to make the beginner's life very easy indeed. Simply point, hit the record button and shoot. That said, it's worth checking out your camcorder's main features and functions to see for yourself what they do.

The main features

All camcorders have a zoom lens, a built-in microphone and the means to see what you are recording – such as a viewfinder or flip-out LCD (liquid crystal display) screen. Your particular camcorder might also have a video light or an accessory shoe to hold a battery light or extra microphone. There will also be a slot, either on the back or at the side, to hold the re-chargeable battery and a socket into which the mains cable is connected. If it is a camcorder that records to MiniDV, Digital8 tape or removable disks, you will find a compartment within the camera where the relevant medium is inserted.

Selecting functions

Not only do we wish to make recordings, but we also need to be able to view our movies as well – either on the camcorder's own screen or on our television set. A main Power switch and selector dial gives us the simple choice, and it is usually accompanied by other controls which we use to tell the camera whether we want to record everything automatically or manually. Controls that resemble those on our home video recorder might also be a feature, as well.

All camcorders have two essential functions – Record and Playback. On this model, they're denoted on the main Power switch as Camera and VCR modes respectively.

What's on the menu

Many camcorders' control functions are now tucked away in an electronic menu system, and every digital camcorder has a Menu button with which your many recording and playback options are selected. It's here you can over-ride auto controls or select particular video sequences to play back, choosing in which order, too. Some camcorders offer a touch-screen LCD; simply touch the icon on the screen to make your selection! In some cases, you can enter your own preferences in the menu, which will be stored for future use.

This viewfinder pulls out from the main body when required and can be used in addition to the more commonly-used LCD screen.

Zooming and focusing

Zooming is controlled usually by a small zoom lever – press it one way to zoom in and the other to zoom out. Focusing will often be performed automatically, but you will often have the choice of doing this yourself if you are creatively inclined! You might also be given the opportunity to manually over-ride other basic functions such as exposure and colour (white) balance, with some models giving you the rare ability to press actual buttons on the body of the camcorder to activate and adjust them.

Getting connected

Look around the camcorder's body and you will often find rubber or plastic caps concealing various sockets. These will include the means to make digital and analogue cable connections to a computer, other camcorders, video recorders and TV sets. Check with the manual about their usage. Additionally, your camcorder might double as a digital stills camera, in which case there will be a slot for the appropriate memory card – such as SD card or Memory Stick.

must know

All MiniDV and Digital8 tape-based camcorders use FireWire to transfer video sequences to computers and similar camcorders, but you might find a little socket labelled 'i.Link' or IEEE1394 (or both) instead. Don't worry – it's all the same thing.

Making your first recording

The time has come to put aside the user manual and make your first recording. You've discovered where everything is and what it does – and even if you haven't there is no stopping you now. Let's attempt a first test recording.

must know

You have to set the Date and Time yourself, by reading the appropriate section of the user's manual. Date and Time information is important in logging precisely when a video clip or still image was recorded, and has tremendous advantages if you ever plan to edit your video footage later in a computer.

Pointing and shooting

Assuming you are bored with the user manual and want to record something, here are a few ideas to get you started. To begin with, make sure that you have inserted either your tape or disc properly and that the camcorder is in Record or Camera mode, which you will have done with the main function selector. If you're in Record mode – for recording movies and not still pictures – the LCD screen will show you what the camera's lens is seeing.

Firstly, make sure you know where the zoom lever is. If you are indoors, point the camera's lens out of the nearest window and then zoom in to a

For your first attempt at shooting your own home video, don't worry about all the settings and buttons - simply switch it to Camera mode, leave it in Auto and hit the Record button!

prominent object – such as a stationary car, a tree, house or a feature of the landscape. Notice that the automatic focus function of the camera takes a short while to deliver a sharp image. That's because it needs something to effectively lock onto – in your case the object that you are looking at. Now zoom out. You will notice that it remains in focus throughout the zoom.

Ready to roll

To make a recording, simply press the Record button. This is often coloured red and is situated either in the centre of the Power/Function dial or close by. You will see the timer counters ticking over in the screen of the LCD or viewfinder – that means you are recording! Shoot whatever comes to mind – the object of the exercise is to get a feel for using the camcorder in a manner that suits you.

Your first playback

It is always important to play back your footage at regular intervals – not just to marvel at what you've achieved but also to make sure that the system is recording properly. To do this, change the function switch from Record (or 'Camera') to Play or 'VCR'. You will need to determine how the camcorder's playback controls enable you to play back the recording. Some tape-based models have VCR-like controls for Play, Rewind, Fast Forward, Pause functions and so on, and these should now be used. DVD and solid-state media cameras will present you with a set of little thumbnail images on the screen. Select the first of these to play back your newly recorded movie footage.

watch out!

If you're using MiniDV cassettes, be extra careful to ensure that you insert them properly into the camcorder's tape compartment. Don't force the mechanism to shut or you will damage the camcorder, which will affect your manufacturer's warranty.

Viewing your movie clips on TV

It's one thing to play back your first recordings on the camcorder's small LCD screen, but it becomes awkward when there is a group of people jostling for a glimpse of themselves on video. Here's how to watch it on a television set.

The right connections

To view what you have recorded on tape or disk in your camcorder on a TV set, you first need to make some connections between the two. All camcorders come equipped with a set of cables called AV connectors. Often – and this is certainly the case with recent models – this will consist of a set of either three or four coloured cables all of which merge into one single plug, called a multiway plug.

With the right connections, it is easy to play back your home movies from your digital camcorder straight to the TV.

This plugs into the AV socket of the camcorder. At the other end, the individual cables will be coloured Yellow, Red and White – and possibly a slightly different Black or Grey cable or plug as well.

The coloured plugs are called RCA (in the USA) or Phono (in the UK and Europe) connectors, are quite often referred to as RCA Phono, and are the ones used to connect to the Video, Sound (Right) and Sound (Left) input channels on the front or rear of your TV set. The single circular plug, on the other hand, is called an S-Video connector, and can be used if your TV has a socket for it. You will get slightly better picture quality. Don't forget to check the user manuals of both the camcorder and your TV if you are still unsure of what to do.

Three RCA Phono connectors carry the video composite picture and stereo audio signals from the camcorder to your TV or video.

Starting playback

Playing back your video footage is now simple. With the camcorder tape rewound (or disk ready for playback), make sure that the TV is switched such that it can 'see' and 'hear' the signals coming in from the camcorder via the AV cables. Once you know you are getting picture and stereo sound properly, you are free to press Play. It's at this point that your family members or friends will be able to marvel at your video skills!

Using SCART

If your TV is equipped with a SCART connector and your camcorder has the right output adaptor, simply connect the AV leads to the adaptor first before plugging this into an available socket on the TV. You'll need to switch the TV to AV, VCR or similar, depending on the particular model.

must know

Have you noticed that the TV screen is full of date and time information, as well as a range of other numbers and symbols? That's because the camcorder's Data Display is switched on by default. Most camcorders have a menu option (called 'Display'. Simply switch this off and you will enjoy an uncluttered picture on the TV screen.

Copying footage to tape and disk

Even at this early stage it is quite possible that you will want to provide another person with a copy of your movie footage on VHS tape or DVD disk. If you have succeeded in viewing your clips on TV then you will have no problem making copies.

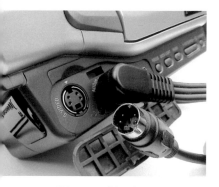

Where possible, always use the S-Video connector when connecting to a TV or copying to a computer.

Checking connections

Let us assume that your videotape or DVD recorder has the appropriate input connections, similar to how you connected the camcorder to your TV set. The difference this time is that the signals from the camcorder must first go to the video or DVD recorder where it will then be 'looped' up into the TV to check what's happening. So, before doing anything else, put a tape or disk (as appropriate) into the recorder and make sure it can be seen and heard properly on the TV.

Having done this, you are ready to connect the cables (or single SCART connector) from the camcorder to the correct input sockets on the recorder. As before, refer to the recorder's user manual if it is not clear. Using the recorder's remote control or the manual switches on the recorder itself, switch it to the Input source relevant to the camcorder – this might be referred to as 'Input 1' or 'AV-1'. You are set up correctly when the camcorder's output is both visible and audible on the TV set. All you now have to do is to press the Record buttons on the recorder to make a copy.

FireWire copying

Many modern DVD recorders, HDD (Hard Disk Drive) and other specialized digital home movie recording systems now provide FireWire (i.Link) or USB 2.0

sockets to enable simple digital connection and transfer from the camcorder to the recording device. If you have such a facility, then use this in preference to the analogue method described above. Picture and sound quality will be much better – and you will have a 'wizard-based' onscreen menu system to guide you.

Taking advantage of S-Video

On the previous page you will have seen that there are two types of analogue video connections – the yellow RCA video-only connector and the rounded S-Video connection type. The yellow connection is a simpler video signal type known as Composite Video – all the bits of the signal that go to make up a TV picture are wrapped together into one signal. You may notice that an S-Video plug has more pins. This is because it uses a method of keeping separate the various components of a video signal until the very last stage. This is called Y/C component video, and leads to a better quality video picture. However, it does require that the original recording has been made in a compatible manner – such as Hi8 or S-VHS tape recordings. If not, it isn't beneficial.

watch out!

When making the connections necessary for copying to another recorder, it's always a good idea to make a brief test recording first – otherwise you will find yourself doing it all again later if there is an undetected fault.

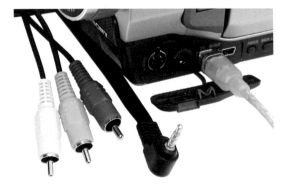

Here's how to feed the VHS player's output to the camcorder, then pass the digitally-converted results to a computer without re-recording to tape in the camcorder.

Adding digital effects in playback

You can have some fun with the many digital effects that are likely to come pre-installed with your camcorder – even when you are playing back footage or making copies. Usually found under a menu setting called Video Effects, or perhaps accessible via a special switch on the camcorder itself, these will provide hours of fun for newcomers to the world of home video! Obviously, the available options vary hugely from one make and model to the next, but you will usually be able to freeze the picture, add weird colourization, strobing and multi-faceted image effects to your movie whilst it is playing back. You will probably be able to zoom digitally into and out of moving pictures, too – very useful for inspecting a sports action or gaining a closer shot of a landscape feature even after it has been recorded.

Adding titles

It is possible to generate titles and captions that can be overlayed onto selected clips without actually recording them to tape. Several DV camcorder makers supply special 'chipped' tapes that enable the storage of text data whose display will be triggered when playback reaches pre-defined points. However, many users are now able to import their movie footage into home computers – Windows PCs and Apple Macs – and in-camera titling is not seen as such a good idea any more. However, it's still possible that in-camera title generation might have a use in situations where you wish to provide a quick visual reference to the location in your raw footage. Place it at the beginning of a shot sequence rather than superimposing it, though.

must know

Remember that any in-camera effects recorded directly to tape will remain permanently embedded within the video recording, leaving no opportunity to remove or even change them at a later stage.

Most camcorders give you the means to create a range of fancy digital visual effects in camera, either as you record or when you play back. These will include Watercolour (above, left), Solarize (above) and Pixellate (left) effects. If you are editing your footage in a computer at a later date, you may prefer to leave such effects until later.

Tapeless camcorders

Although the idea of recording onto digital tape in a camcorder might still be a novelty, we are seeing a rapid shift away from tape formats in favour of those that use either re-recordable disks, memory cards, hard disk drives and the like. The tapeless revolution is on its way and there will be no turning back.

Digital camcorders that use DVD discs, hard disc drives and memory cards rather than tape, are commanding an increasing share of the market due to their uncomplicated ease of use and accessibility.

Tapeless recording – for and against

Tape no longer rules the roost. It is now possible to shoot your home movie projects onto re-recordable DVD disks, to flash memory cards or even to high-capacity small internal hard disk drives.

The reason for this expanding choice is simple: those companies engaged in the development of

data storage and retrieval technology can now manufacture disk drives and solid-state memory chips capable of holding a very large amount of information and which have the ability to move it around at astonishingly fast speeds compared to only a few years ago. Soon it will be 'goodbye tape' forever.

HDD camcorders are gaining in popularity due to their high storage capacity. Models such as JVC's Everio G range can store up to 37 hours of footage at an 'economy' resolution setting.

Recording onto DVD

Camcorders that record direct to DVD disks are gaining in popularity, and can simplify the process of recording, playing back and sharing home movie projects. DVD camcorders use 8cm re-recordable DVD disks (2cm smaller than the ones we are used to) which can provide up to 60 minutes' recording times – depending on the quality settings used. Once recorded, it is generally possible to insert

must know

Tapeless camcorder formats such as those mentioned here all use a compression system called MPEG2, which is more difficult to edit accurately with appropriate computer software and hardware due to the complicated way the picture sequences are compressed. If you are looking for quality and editing accuracy – don't discount MiniDV!

them into a home DVD player for viewing on TV. Depending on the hardware in use, it is also possible to connect the DVD camcorder to a digital recorder in order to recompile sequences to a new disk, after which the 8cm disk can be erased and used again.

Recording to internal HDD

Several camcorder models employ neither tape nor DVD disks to save and replay video clips. The increasing range of HDD (Hard Disk Drive) digital media cameras contain small disk drives – not unlike those used in portable media players like Apple's iPod range – to store your video clips and make them available for replay in any sequence direct from the hard disk. In order to cram so much data onto a typical 30GB (gigabyte) HDD, a system of compression that is used with DVD called MPEG2

Hard Disk Drive (HDD) digital media cameras are becoming more and more popular with camcorder users.

is employed. Although it reduces the quality of video in much the same way that MP3 files are more compressed than commercial CD music tracks, the outcome is virtually indistinguishable from DV in most situations.

Solid-state media cardcams

Although HDD cameras provide instant access to clips at random, they still rely on moving parts inside the drive. So-called 'card-cams', on the other hand, have no moving parts at all. They use small memory chips – such as high capacity SD Cards and Memory Sticks – to store clips, and give you exactly the same control over your recordings as is achieved with the memory cards used in digital stills cameras. Developments in technology mean that they can now handle large amounts of data and process it very quickly. Surely, this is where the future lies?

With a capacity of 4GB, the very latest SD HC (High Capacity) Speed Class 2 memory cards can hold almost as much video as a standard 10cm (4in) DVD.

Selecting, moving and deleting clips

The big advantage of tapeless recording is the 'non-linearity' of the recording media. All the systems mentioned here make it very easy to play clips individually and out of sequence; we can instantly rename clips and – if they are no good – delete them altogether. Playing out to an external recorder or TV is simple, too; simply set up a Playlist of your favourite bits and press Play! Thanks to high-speed USB 2.0 connectivity, you can connect up the unit to a computer and copy your clips over in super-quick time, where you can add music, titles and even make identical copies to send to others.

Choosing the recording media

It has long been the case that good-quality video recordings require the highest quality recording tapes and discs, but as we are now in the digital age it's not as important as it used to be. However, there are still good reasons to stick with familiar brands.

Sticking with one brand

Those who use DV camcorders will probably use the same brand of tape in their camcorder for months, if not years. Only when they decide to use an alternative brand or type will they suddenly encounter problems with recording and playback. The reason is simple: videocassettes as small as MiniDV each have their brand-related characteristics that camcorders get used to handling.

It is said that a sudden change in tape stock can introduce a different variety of lubricant into the camcorder's highly delicate transport mechanism, resulting in a clogging-up of the microscopic recording and playback heads. It's a common occurrence, so when you find a brand that works for you, it is worthwhile sticking with it.

Rewritable DVD disks

The same can be said of rewritable (and even once-only writable) DVD disks. As you can imagine, the packing density of data onto the incredibly fine surface of a blank disk is such that we are bound to encounter subtle differences in the way that a particular brand of camcorder will be able to use a given disk. In fact, this is very common indeed – and the main reason why a manufacturer will always

Thanks to the increasing affordability of DVD camcorders, they're now ideal for families looking to have fun shooting high-quality home movies.

recommend their own tried-and-tested brand of recording media.

Mixing and matching

It is possible, of course, to use a JVC MiniDV cassette in a Sony, Canon or Panasonic camcorder. There's no real danger involved in relying on a so-called 'alien' brand in this sense, but be careful to stick with a particular formulation that you know works well, and don't swap to another without good reason.

watch out!

If you're planning to acquire a digital tape based format like DV, try and stick to the same brand and type of cassette. Regular swapping of tapes will lead to clogging within the system, with the result that the camcorder may let you down at a critical moment.

Be your own critic

Playing back your first recordings is always great fun, but after viewing your early attempts two or three times you will begin to acknowledge their shortcomings and will see room for improvement. Common mistakes are easy to rectify, however.

Play it again

Having recorded some home video footage with your new camcorder you will have noticed just how unforgiving it can be. Some members of your family or close friends won't like the way they look or sound on camera, whereas children tend to fall about with laughter when watching a playback of simple things like pulling faces at the lens or performing silly pranks. If that accurately describes your first recordings then don't worry – yours isn't unique!

Getting it right next time

Take the opportunity to look more closely at your own efforts behind the camera. You will probably notice

You'll quickly learn that the best and most natural shot sequences arise from not zooming or moving the camcorder around unnecessarily. For the best results, stand back, hold tight and let the action speak for itself.

A seaside vacation is the natural choice of an occasion on which to get to know your new camcorder, so don't be afraid to experiment by using whenever and wherever you can – it is the best way to learn.

that there is much you can do to improve the quality of your movie techniques – even at the most basic level. The most common mistakes made by first-time users include not holding the camcorder properly, 'hose-piping' the scene in front of the lens (incessantly moving the camera around and not keeping it still for any length of time) and talking over the soundtrack. All of these can be corrected the next time you switch on the unit and prepare to record.

Tunnel vision

Analyze every shot sequence you have recorded. How steady are they? Are your viewers able to relate to what's going on in the scene because you have presented them carefully and in a way that they can understand? Or have you simply recorded what you

must know

Keeping in focus is simple. Zoom into an object and let the camera's lens focus on it automatically. Now switch the focus to 'manual' and zoom out as you frame your opening shot. When you zoom in during recording the close-up shot will be sharp.

A breathtaking panorama from the hills behind a coastal town unfortunately looks flat and uninspiring when played back on the TV screen - especially if the camcorder was hand-held and zoomed-in!

see in the same way as your eyes see what's before you? The human eye looks at a scene differently to the way a camcorder captures it, so you have to think much more carefully about how your viewers will perceive on the TV screen what you can see in reality.

Hold steady

Many of your problems can be easily rectified simply by holding the camcorder properly. Most new users wave it around whilst viewing the LCD screen at arm's length and zooming constantly, but it is much better to grip the cam firmly around the body and keep the zoom control away from temptation. Frame shots as if you were taking still pictures and let the action happen in its own time. Do not wave the camera around and stop recording just when things get interesting. Again, think of your viewers.

Avoid unnecessary zooming

One of the reasons why so many home movies contain lots of zooming is that the zoom control is in a very convenient location under the user's right forefinger. There's something uniquely tantalizing about zooming and zooming out, and perhaps that's

the reason why most new users succumb to the temptation more than is good for movie-maker and viewer alike. Sometimes, of course, the use of the zoom can have a dramatic effect; a close shot of a person walking on the beach which quickly pulls back to reveal that the camera is on a cliff-top and the walker is a great distance below us will always elicit approval from those viewing. The zoom lens is also a useful way of ensuring that your shots are sharply in focus when choosing to shoot in manual focus mode. To achieve this, zoom in to a close shot of your focus and make the required adjustment. Once you're satisfied that it's in focus, zoom the shot out to your starting frame and begin recording.

watch out!

If you talk to those in front of the lens as you record the scene with the camcorder, you are actually stuck with lots of potentially embarrassing conversation which you can't always edit out later. It's best to remain silent when recording and rely on the sound being produced in front of the camera!

Here is a wide vista of the rugged north Cornwall coastline. Notice how the ruin of the tin-mine buildings on the left add three-dimensionality to the image.

What's in the menu

Although the majority of today's digital camcorders offer more features and functions than ever before, it is often necessary to explore the many available options via the on-screen menu system rather than by using physical buttons.

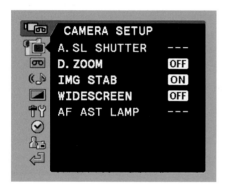

Most digital video camera menus now offer a host of multi-layered options.

Exploring menu options

The days when camcorders came laden with lots of buttons are long gone. There's a price to pay for increasing miniaturization of not only the components contained within them but also of the size of the models themselves, and that is that you will have to dig deep in order to find a particular setting. Although the menus of each brand provide access to similar options, they are also designed in slightly different

must know

Setting the Date and Time in your camcorder's menu is very useful, since the information is digitally embedded into the data stream of every recording your make and every picture you take. It's useful means of searching for those elusive shots later, too, and it helps enormously when it comes to editing later.

ways. To access the menu, you normally have to click a button on the outer body labelled as such. Once you are in, it's easy to scroll through the choices using either a thumbwheel, miniature joystick or touch-screen controls on the LCD screen itself.

Selecting and saving default settings

The camcorder's default settings will enable you to get started immediately, but you will soon want to change things to suit your particular needs. A quick rummage through the system will reveal many automatic settings, with some models having many more options that can be controlled manually as well as in the 'auto' mode – things like focus, exposure, white balance and sound recording. Most camcorders allow you to establish pre-sets to suit recording in particular settings, such as on the ski slopes or in bright sunshine. In time, you will master all of these with ease.

Getting to know what the presets represent and the optimum ways in which they can be applied will improve your work considerably. By experimenting with different settings in different lighting situations you'll discover which works best. Knowing how to over-ride automatic settings such as shooting with a 'daylight' setting as the summer sun is going down will result in dramatic skies that have a reddish hue.

With the many varying menu systems in use in today's camcorders, it can sometimes be a time-consuming job exploring all the sub-menus and options contained within them. Perhaps the apparent complexity of these menu systems – coupled with the miniaturization of the camcorder's main buttons and controls themselves – is one of the

watch out!

Having switched to a manual AE (white balance) mode, it's an easy mistake to leave this mode activated when later shooting in other situations for which a different setting should be used. Until you've developed a routine, it's a good idea to reset everything to Auto. That way you're covered, whatever you do.

reasons why lots of first-time camcorder users opt to record in Automatic mode all of the time. Certainly, the menu systems do appear, at first sight, to be tremendously complicated, but closer inspection – coupled with even a cursory glance at the User Guide or Manual – will suggest otherwise. Although there's no doubt whatever that the overall quality of the footage you shoot will improve in proportion to your preparedness and ability to master the manual controls of the camcorder, it's also a daunting prospect for the majority.

What menu systems do offer you, of course, is the ability to tell the camcorder how you wish to work and not the other way round. It's all very well your shooting everything in Auto mode, but there will be times when the camcorder's electronic or optical circuits will induce an over-ride to a setting at the worst possible point, in creative terms. If you know what you're doing, you can avoid this – and that's why it's vital to understand the many controls available to you.

must know

Some camcorders enable you to create shortcuts for those functions you wish to use regularly so you can access them quickly. This makes it easy for you to change white balance settings, focusing options or other key preset changes without having to navigate through menus while recording is underway. Call up a programmed setting and the camcorder will switch to it immediately.

Camcorders that record to tapeless media provide immediate access to clips, thanks to thumbnail representations on the LCD screen.

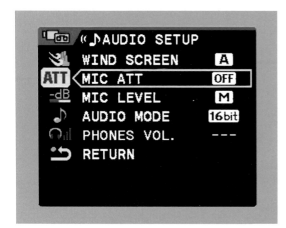

Another equally important menu from a different camcorder model to that featured on the opposite page. In this case, you can see the range of basic audio functions offered on almost all digital video camcorders.

Setting basic operational functions

In addition to the standard set of White Balance preset controls referred to on the previous page, you'll also find a number of settings relating to key functions such as the rates at which the digital stereo sound is recorded to tape or disk (denoted as either 12-bit or 16-bit stereo audio), electronic shutter speeds, exposure levels and focus. In addition, there will be options relating to extra features offered by the camcorder itself, such as manual sound level control and 'wind cut' audio filters designed to reduce the effect of wind beating the outside of the built-in microphone. Such settings exist to aid and enhance your control of these factors. The downside of a dependence upon built-in menu control of many key functions is that you'll have to keep one eye on the viewfinder or LCD whilst simultaneously adjusting a control using either the thumbwheel or – more complicated still – options that present themselves on a camcorder's touch-screen LCD monitor. It takes practice, but perseverance pays off in the end.

watch out!

Whilst many camcorders allow you to make adjustments via the menu as you are actually recording, they also create a sound tone or bleep as you make your selection. Unless you switch this off it will be picked up by the microphone and recorded as well.

Exploring manual controls

Many camcorder users continue to make family recordings for years in fully Auto mode without ever taking control of key functions manually. However, there are hidden pleasures in telling the camcorder what to do and how to do it.

Taking control

All but the most basic camcorders and so-called digital media cameras offer a choice of fully automatic and manual control of key functions, such as focus, exposure, white balance and sound input level. Of course, the models that are on the market today are unlike those of only a few years ago in that their auto circuitry is designed to deliver excellent pictures and sounds in a wide range of situations to a really high technical standard. However, that is no reason why you shouldn't explore and try out some of the features manually for yourself.

In this shot, we have been able to throw the background out of focus with good effect.

Some of the more expensive, professional-quality camcorders will have zoom rocker switches that make manual control of zooming much easier.

Why do things manually?

Take a look at your early video footage and look for sequences in which the picture goes dark or out of focus. You might have taken an interior shot against a large window and realized that the incoming light has a blue tint. What's happening is that the automatic circuits are reacting to too much light, changes of focal points and mixed colour temperatures. In short, we need to take control of exposure, focus and white balance. Once we have done that, the whole thing will look more controlled – professional, even!

When to consider manual operation

There are several instances where taking manual control will benefit your shots. A common technique is to frame a shot on an object very close to the camera and then gradually shift the focus from the foreground to the scene beyond. You really need manual control of focus to achieve this. The same principle applies to exposure and white balance – take control and you will achieve much better results overall.

must know

Manual control is sometimes achieved by turning a thumbwheel to make the adjustment, whilst others have either joystick control or even touch-screen operation in the LCD. If you have the chance, check these features out before buying.

Temperature control

Few of us are aware that light has varying colour properties until we play back our footage and note that there is a light cast that did not appear to be there when we made the recording. We need to think about colour temperature.

Looking at the colour of light

Human beings are very clever in processing the information that they receive from their eyes and making adjustments to the colour temperature of light in a way that is completely transparent. It's for this reason that we find it odd to see film, video and colour photographs containing blue, red or yellow/green light where it didn't appear to exist

In this image, the proper Daylight white balance setting has been used. You can see that colours and definition are as you would expect and nothing looks unusual.

at the time of recording the image. The spectrum of light has a range of properties – and those engaged in the business of recording what we see are aware of what we call 'colour temperature'. In video, we use a White Balance control to manage the differences.

In contrast, this image demonstrates that the colour balance setting is incorrect, with the camcorder having been set to an indoor (tungsten) light setting – hence the blue cast on the image.

Daylight versus artificial

The 'temperature' of light is measured in degrees Kelvin (°K), with the colour value of daylight on a sunny day at 12.00 midday being 5,600°K. At each end of the day – dawn and dusk – the colour temperature of the light will be nearer to 3,000°K. That's why the rising and setting sun in a clear sky has the effect of producing a reddish hue, which is less evident as midday approaches. The light produced by artificial halogen-type lamps – such as

must know

Recording video clips in offices and other places which use fluorescent striplights can cause problems due to the yellow-green hue they give off. Try and keep such light to a minimum by switching them off.

must know

If you are filming in churches or other public places with large windows which are also being lit from inside artificially, this will lead to a mixture of light in your camcorder images – blue and red tints in the same picture. Try and frame in favour of one or the other.

videolights or even the halogen lamps obtained to illuminate your garden at night – have a colour temperature of approximately 3,200°K. The tungsten lamps that film and video crews use have a 3,200°K colour temperature too. So, in general, we refer to daylight as having a blue value and tungsten artificial light as having a red tint. All cameras and camcorders are sensitive to the differences – some more than others, depending on their degree of sophistication.

Exploring White Balance

Cameras and camcorders need to know about the colour temperature of the available light before deciding how to process it. Essentially, that entails it being told whether the light is natural daylight (5,600°K) or artificial tungsten light (3,200°K). That does not involve you in any extra work, however; you could leave things switched to Auto and leave the camera's own circuits to decide. However you may wish to override this and experiment for yourself.

Explore your camcorder's menu system (or look on the outside for a physical switch) labelled 'WB' – White Balance. White Balance is a term used to describe the optimizing of the light that comes off an even, bright surface – such as a piece of paper. When the image looks white in the viewfinder or LCD screen, the camcorder's white balance is said to be correct, and it will now see the scene before it properly. Many low-cost consumer camcorders will do this automatically and you won't be aware of it having done so. However, there are times (such as when you are experiencing mixed daylight and artificial light) when you may wish to set it manually.

All modern camcorders offer a set of 'AE Presets' with which to manually select the desired White Balance setting. These contain a range of everyday settings, though if you shoot in AE Auto the appropriate setting will be chosen automatically.

When to use AE presets

Many cams offer a range of settings enabling you to switch from one White Balance setting to another. There is usually the option of a number of pre-set values designed to optimize the lighting conditions with the image processing in the camcorder. These are called 'AE' pre-sets – and will often include Beach, Sports, Portrait, Low Light, Spot Light, Surf & Snow and so on. Point the camcorder at an interesting scene and flip through these options to see what the effect is on playback. You will be surprised at what effect the different colour temperature values have.

Mixing light sources

There will be times when you have to mix natural daylight and artificial tungsten light. In general, today's camcorders have circuits which are more than capable of working out the distinctions for themselves and producing images that do not look out of place to the average viewer. However, it's worth experimenting with different manual settings to see exactly what can be achieved by mixing light sources and even breaking a few rules!

watch out!

If you shoot under indoor lighting with a WB filter set to daylight, the image will have a blue tint. Conversely, if the WB is set to 'indoor' and you are filming in daylight, it will assume a reddish tint. Always reset the camcorder's WB function to Auto in the first instance to begin working with the correct setting.

Working with timecode

Unlike the tape counters of old, which would reset to zero as soon as the tape was removed from the camcorder or VCR, timecode embeds really important data into the digital recording in a way that can make your life easier later on.

must know

In those parts of the world where video is recorded and displayed at 25fps, we refer to the transmission system as PAL, a TV system that uses 625 lines to make up a TV picture. In those areas that use 30fps (although strictly speaking it is 29.97fps), the 525-line system is known as NTSC. PAL is used in the UK and NTSC is used in the USA.

What is timecode?

Timecode is something that professional video-makers have come to regard as essential to the process of video, TV and film production and – thanks to the popularity of digital video camcorders in the home – it is a utility that can add significant benefits to the way you work with video. Even if you don't intend to copy your camcorder sequences to any other medium – for instance, to a video recorder or to a computer for editing and creating DVDs – timecode can be extremely useful.

At its simplest, timecode is just what the word suggests – a measure of the duration of a recording, with the time being measured in hours,

The timecode numbers in the top right of the camcorder's viewfinder indicate the hours, minutes and frames that have been recorded to the tape in the camcorder.

minutes and seconds, as you would expect. So, in pausing the tape at a given point, the camcorder will tell you that it's paused at (for instance) 00:20:13. What do these figures mean? Well, the tape is less than 60 minutes long, so the first two zero digits haven't yet counted any hours of recording. The second and third values are minutes and seconds. So, we are paused at 20 minutes and 13 seconds from the beginning of the tape. That's quite obvious, actually, but don't go away – stay with me!

Counting frames

The point where it gets slightly more complex is that a second of video recording is itself made up of frames, with there being 25 frames per second (fps) being recorded in many countries – most of Europe, South Africa, New Zealand, Australia to name a few – and 30 fps in the USA, Canada, Japan and many South American countries. The different video frame-rates relate specifically to the type of television broadcasting system used.

So, where 25 fps is the norm, we might have an additional value on the end of our timecode reference. If we consider the 12th frame being equivalent to half a second, our exact time might then be displayed as 00:20:13:12 – hours, minutes, seconds and frames.

This 'frame accuracy' is what helps you to find the exact point of a clip, and furthermore it never varies because it is embedded in the data that is recorded with the shot, whether or not it is displayed on the screen.

The Data Code function contains date and time information that will be of great importance at the later editing stages.

Built-in camcorder effects

Many digital camcorders have an extensive range of digital video effects built in and available to use in an instant. Whilst they are likely to provide hours of fun for the children at the outset, there are good reasons why you should avoid using them on your important video sequences.

watch out!

Take extra care when applying such effects to shots that are being recorded onto tape in the camcorder – you can't change them later! If you are planning to compile your movies in a computer, leave all effects until later on.

Lots of mattes will often be supplied on the card. The camcorder replaces the blue area in the centre with the video footage you are taking for the two to be mixed on the recording.

Source of instant pleasures

Flicking a switch that turns a shot of old Uncle Arthur into a posterised, pixellated negative humanoid is fantastic fun to begin with. Thanks to digital processing and the ease with which modern camcorders provide instant access to all manner of weird and wonderful video effects, it is very easy to flick a switch and turn everyday shot sequences into something completely out of this world. When you or a group of kids are simply messing around, then it's a good fun thing to do. However, in most cases the recording will be committed to tape – and on tape there's no 'undo' key, so once you have made those oh-so-hilarious-at-the-time amendments to your video footage, that will be that!

Selecting digital effects

All home video camcorders give you the chance to have fun with digital picture effects, the range of type varying according to the make and model in question.

Sooner or later the kids (and even some grown-ups) will discover the amusement potential that exists with the choices of digital video effects on offer in the majority of consumer digital camcorders.

Incredibly, many of these effects are features that would have cost a small fortune to apply in the professional world a mere two decades ago, and the fact that they are readily accessible in a budget-priced camcorder today means that they are there to be explored – often to the considerable amusement of friends and family members.

Adding effects in playback

Many models of camera allow you to add special video effects whilst the camcorder is playing back the tape and being viewed on a TV set. It could be that you are making a copy to a VCR or DVD recorder, as well; in all cases, you may decide that experimenting with effects at this stage is preferable to committing them to the tape as it is being recorded. This way, at least you would not be stuck with them as their appeal wears off.

Image overlay mattes are usually held on the camcorder's SD card or Memory Stick, with fun effects being available at the flick of a switch as you are actually recording. Beware, however; once they are committed to tape they are there forever and cannot be removed later on.

want to know more?
• Experiment with the creation of your own in-camera mattes using Photoshop Elements or Paint Shop Pro in your computer.
• Join a camcorder club to learn new skills and techniques from existing videomakers and take part in group projects.
• Log into a web discussion forum and gain tips from existing video makers.
• Check the Bibliography section on page 189 for suggestions on books to improve your video-making techniques.

weblinks
• Visit the Amazon website for books on video technique at www.amazon.co.uk
• Visit the SimplyDV camcorder user forums at www.simplydv.co.uk
• Visit the *What Digital Camcorder?* magazine website at www.whatcamcorder.net

3 Basic shooting techniques

The concept of editing is something that frightens many camcorder newbies who think of it in terms of complicated processes and expensive technology. However, if you are thinking about what you are recording and considering each sequence in terms of what came before and what is to follow, then you are already editing. Editing has more to do with the process of selection and construction than it does with pressing buttons and risking the deletion of everything you have recorded. In this section, we'll give you some pointers on how to improve the look and feel of your footage as you learn new skills.

Editing in camera

As soon as you power up your camcorder and point it at a subject in readiness to record, you are making a subjective decision about what your viewer is to see. Take successive shots on the same subject and then you have a sequence. This film-making process is called 'editing in camera'.

must know

When recording people in conversation, give the characters involved space to breathe, so to speak. Eavesdrop on the conversation, but record enough to make the resulting sequence of interest to the viewer. Don't chop and change too quickly.

Breaking down a scene into shots

If you have ever had to endure home movies made by well-meaning relatives and friends, you will know that the most common characteristic is the chaotic nature of the content. Most people don't think about what they're shooting when they hit the Record button, and neither are they thinking about the effect on those who view their efforts later on.

Perhaps the most common mistake made by most video movie-makers is what is known as 'hosepiping'; that is, not pointing the camcorder at anything specific, but spraying it around at what's in front of the lens in the same way that you would use a hosepipe. The effect is to produce a video recording that is almost unviewable. However, it is all avoidable.

Creating points of focus

Rather than hosepiping a scene with the camcorder in no structured manner, isn't it better to take shorter, better considered, shots in sequence rather than a lengthy shot that starts and ends in confusion? Look at the sequence of shots opposite. Before pressing the camcorder's Record button in each case, each shot was framed properly in order to observe the action before deciding to record it.

1 A young man and a boy are fishing on a quiet inland waterway. The first shot of them is taken from a 'standing' perspective. The boy has been throwing handfuls of grub bait into the water and a canal boat can be heard.

2 In the second shot the camera comes around to a rear-left shot in which the boat is seen travelling through the picture from right to left and you can clearly see the pair fishing on the banks of the water.

3 As the boat passes through, we then cut to a closer 'over-the-shoulder' shot designed to show the viewer that the box is full of live maggots – and the boy isn't afraid to put his hand in!

watch out!

When breaking down a piece of continuous action into separate clips, be aware of the sound. If a person is talking, think about where you will stop and start – you want it to make sense when played back, so don't cut in the middle of important sentences.

Planning for editing

If you can edit in camera and produce sequences of clips that make sense to your viewers, why think about editing outside of the camera? Well, if you have a reasonably powerful computer and the means to transfer your recordings into it digitally, why not start editing proper?

1 We start with a shot of a stationary locomotive, preparing to go.

2 The camera is brought in closer to the locomotive. The whistle blows.

Thinking ahead

A normal home video that will only ever reside on the tape or disk on which it was shot will also be viewed in the sequence in which it was shot. Unless, of course, it is a disk-based format, in which case you can set up a play-list when showing others your movie-making efforts.

However, the majority of us now have DVD players in our homes and it is natural that we should wish to show off our efforts in this medium. What's more, an increasing number of users have the desire to produce a special web-ready version of the movie for emailing to others or including in a web page. That's where you need to be able to edit.

Telling a story

Editing requires that you think ahead from the second you switch on the camcorder, and even if you plan to tidy up all of your raw footage in a computer, it's really important to have an idea of how it will go together. We are not

talking about complex editing of Spielberg or Jackson proportions here, it is simply a case of getting sequences of shots that convey some meaning and tell a story through a combination of pictures and sounds.

So, as you saw on the previous two pages, it's always best if you look at ways in which you can break down a scene into separate components. When you begin to compile your sequences in the computer, you will be impressed at how easily all the bits go together – and how much it looks like real films and TV!

Continuity issues

In simple terms, 'continuity' is a term applied to a process of getting the viewer from A to B without feeling that there is something wrong about the way the shots have been put together. This you can see from these images, which represent a sequence of a steam train leaving a railway station deep in the English countryside. We could have simply waved the camcorder over the scene in order to catch everything by chance. Instead, we have stopped to think about what shots might tell a story when edited together in an appropriate sequence. It's not necessary to edit them together in the sequence depicted, of course, but that is where the benefit of shooting to edit comes into play.

3 Cut to a closer shot of the wheels beginning to turn, slowly.

4 The camera turns in the opposite direction to see the train moving away.

5 Cut back to a 'reverse' shot of the previous shot as the train gathers speed.

6 The final clip is a long-shot of the train disappearing into the distance.

Shots that set the scene

Our movie tapes and disks very rarely contain footage shot at only one location. Usually, they will consist of sequences that have been recorded in a variety of locations, but how will your viewers know which is which?

Establishing shots

An establishing shot at the beginning of a new sequence or location performs the task of giving us an instant visual impression of where we are. So, if we're intending to show a selection of shots of a yachting harbour, it's a good idea to begin with a wide shot that makes a statement. Whilst it might be not so precise as to identify the exact location, a wide shot of a harbour is still enough to tell the viewer that we have moved from our previous location – which could be a ski slope!

The establishing shot is another of those techniques employed by TV and movie makers to get us from one location to another, and although you probably don't recall any one

Place this shot at the beginning of a sequence and your viewers will gain an instant impression of where you are and what they're about to see. That's the power of a good establishing shot.

All the world's major cities have their iconic images. In this shot, it doesn't take much to work out that you're in London. You could superimpose a title caption – but do you really need to?

instance when you have seen an establishing shot in use, there is absolutely no doubt whatsoever that they will have passed before your eyes many times.

Counting time

A good establishing shot doesn't have to be on screen for long, but it does need to convey enough information for your viewers to understand what you're aiming to get across. When you're recording it, therefore, select the shot carefully and record more than you'll need (this is especially important if you're planning to tidy up your footage later in a computer). A good rule of thumb is to allow an establishing shot to remain on screen for at least three seconds; count to three in your head, but intersperse each number with the word 'elephants' in order to get the right timing. Check it with the seconds hand on your watch – it works!

Tell-tale signs

An ordinary, everyday, road sign acts as a perfect establisher shot in that it tells us immediately where we are. Follow this with a shot of a particular building or landmark, and you are immediately drawing your viewers in – and without even realizing it you are also telling them a story in visual terms.

Making good use of close-ups

Getting in for a nice big close-up shot is something many of us are reluctant to do for some strange reason, and yet it is often possible to get some of the best, most engaging shots by literally moving the camcorder closer to the subject.

Zoom out wide, get in close

Part of the reason why many people don't feel comfortable about getting those juicy close-ups is because it is perceived to be rude and imposing upon a person to get too close. That is understandable; however, in movie-making you are allowed to stray into unknown territory for the sake of your art – so take the opportunity to get in close whenever you can!

The convenience and availability of the zoom lever or rocker is another reason why people don't exploit the potential of the close-up. It's assumed – wrongly – that by standing-off and zooming in that the required effect can be gained, but you will end up with an image that looks and feels completely different. There

must know

When you are in close to your subject, be very careful to avoid unnecessary movement as this will cause the auto-focus circuit to hunt around and run in and out of focus. The steadier you are, the better your close-up shots will be.

By getting in close after zooming out wide, you will not only get better quality close-ups, but will also help to regulate the auto-exposure for the baby's face.

Believe it or not, this image was shot with a camcorder whose lens was virtually touching the flower, thanks to an excellent Macro facility which switches in when automatic focus is engaged.

is only one way to get a really good close-up and that is to get in close. As a precaution (you don't want focusing problems), make sure you have zoomed out fully to the lens' widest setting. Now physically move in close, manually controlling the focus to the point where the camcorder is virtually touching the subject.

Some camcorders, such as the slightly more expensive models, will have a built-in Macro facility that allows you to virtually touch the object in front of the lens. This can produce an even more impressive visual effect, and is well worth experimenting with.

Stability issues

There is another reason for remaining fully zoomed-out when grabbing big close-up shots, and that is maintaining stability while you are recording. It is more difficult to retain a steady shot if your camcorder is zoomed in while hand-holding, so zooming out and getting in close will automatically render your shots more stable, providing you grip the camcorder properly. As with everything else, continued practice will produce excellent results in the longer term.

Zooming and panning

In much the same way that beginners have a tendency to hosepipe a scene whilst recording, so the majority of first-time users have a natural tendency to make full use of the zoom control – whether a shot needs it or not!

Zoom in moderation

As you pick up a camcorder for the very first time, the first control you will use is the zoom button. Guaranteed. All beginners love zooms, believing it's one of those utilities that really must be used to the full simply because it exists, and because it enables us to make instant (and even constant) changes to the shot whilst recording. Without a doubt, the over-use of the zoom control is the one factor above all others that contributes to home video footage that is unwatchable. However, if used carefully, a steady zoom in or out can add punctuation and emphasis to a shot or sequence.

When not to use the zoom control

Most people – even experienced users – use the zoom for all the wrong reasons. For a start, they forget that a video camcorder's lens and imaging system see a scene completely differently to the way the average human eyes see it. It's quite natural for us to scan a scene in an attempt to take in as much detail as possible in a short space of time. We do it subconsciously, and that's why our eyes (which observe a scene stereoscopically) communicate a very complex set of signals to our brains. The big difference is that it's only

must know

In order that a subject will be in focus after you've zoomed into it, switch the camcorder to manual focus. Having done so, and before recording, zoom in and set the focus manually. Now zoom out and press the Record button prior to zooming. It will be sharp – guaranteed!

With this striking panorama, there is every opportunity for a lengthy zoom out within an establishing shot, but only if you are using a tripod!

ourselves who actually see what our eyes are really focused upon.

A camcorder is focused on a scene usually because the user wishes others to see the same scene at a later date, so it is no good treating it as if the camcorder was never there – we need to control what the camcorder sees and records.

Abstaining from zooming

The zoom can be addictive, and it is very easy to use it without being aware of the fact that it's constantly creeping in and out during a recording. That's because many users are looking at the subject of the shot rather than how it is composed. Does that sound silly? Look at your footage to date, or look at somebody else's, and you will see what I mean.

With a shot like this, there's every temptation to use a zoom – but does it need it? Zooms can add to the impact of a shot within a scene, but sometimes it's better to leave the shot to tell its own story when part of a sequence.

The zoom diet

The best thing you can do to bring about an instant improvement to your footage is to refrain from using the zoom altogether. Like all addictions, it's not easy – but it can be done. Once you have got past the withdrawal symptoms you will be amazed (as will others) at how professional your video footage looks. Now, instead of zooming and hosepiping all over a scene, you are now forced to find an establishing shot, a good close-up, another good close-up, and so on. It's actually really easy!

Panning shots

A 'panning' shot is one in which the camera or camcorder is moved from left to right or vice versa. The term is derived from the word 'panorama',

meaning wide vista. We might pan when creating a shot of a beautiful landscape or a busy scene. It might also be necessary to pan with the motion of an aircraft as it takes off at an airport. As with zooms, think carefully when panning; give a couple of seconds' still shot at the beginning and end in order to give the viewer time to understand what is going on and to appreciate the scene.

Counting the beats

When taking shots, don't rush into any movement the second the tape or disk has started to record. After pressing the Record button, count to three in your head slowly and carefully. Now perform the planned camera move – perhaps while it's mounted on the tripod. Having got to the end of the desired shot hold it steady for an equivalent number of beats. Now you can stop recording.

watch out!

Don't be tempted by Digital Zoom ratios. A digital zoom is not like a normal optical zoom – it digitally blows up the image to the point where it's little more than lots of square boxes. The higher the digital zoom magnification, the less detail you will see!

Here's a bit of covert filming that might well require the use of the zoom control due to the near impossibility of getting the camcorder any closer to the action.

Looking at light

Many new camcorders have an ability to perform reasonably well in conditions of low, or even no, light. However, grey and murky images that lack definition are no substitute for nicely exposed images that do justice to your movie project.

must know

When shooting in conditions of mixed, or difficult, lighting sources, it is important to take manual control of the camcorder's exposure controls and find a setting that suits your needs – not those of the electronics in the camera itself.

Let there be light

Good lighting is integral to any shot worth keeping. After all, without light there is no image. It's odd, therefore, that many users seek to shoot in conditions of virtually no light, only to complain later about the camcorder's shortcomings. Learn to use light to your advantage.

Looking at light

On pages 60–3 we discussed how light varies in colour according to its source. Artificial light possesses very different characteristics to daylight emanating from a bright sun at midday. Whilst there is no shortage of light on a hot and sunny beach, the

Here you can see people gathered at a reception in a large room into which strong light pours in through a tall window, forcing the camcorder's auto-iris down and putting the foreground subjects into silhouette.

quality of shots can still be significantly impaired by not making the best use of the available light source. Similarly, if you are recording indoors where there is a mix of artificial light and daylight, your shots could well take on a strange mixture of blue and orange light. It is important to consider carefully where you will take the shot in relation to the source of light.

Shoot with the light source

With few exceptions, the aim is to shoot a subject in such a way that it is amply illuminated by the available light. That might mean that your shot of the kids on the beach will be aided by an ample supply of direct sunlight. Similarly, a shot of granny in her armchair telling us her life story will be all the more interesting if we are able to see her as she speaks. It may seem obvious, but look at other people's home video and you will see plenty of examples where people are seen only in silhouette due to their having been filmed against a bright window. How can these mistakes be rectified?

For a start, we can either move the position of the camcorder – or the subject. If granny is seated in her favourite armchair and reasonably close to a large window through which the sunlight beams, then consider moving her to a position which takes advantage of the incoming light.

1 Here's a simple example of the way in which your position in relation to the source of light can affect the image. The sun is just out of frame, top left, and the camcorder's iris circuit is forced to compensate. This leaves the foreground subject in silhouette.

2 The solution is to move where the sun is behind us. Now the subject is properly lit, with the sculpture consequently given a three-dimensional quality. Note how different the sky appears, too.

Coping with fast movement

Part of the fun with a camcorder is gained from shooting sports and action of all types. However, it's important to have an appreciation of some basic problems that can be encountered when shooting objects that whizz past the camera in a split second.

Using a tripod for support

The first and most obvious thing to do is to ensure that the camcorder is properly supported. There will be times when hand-holding the camcorder will be preferable – particularly those instances where you need to be flexible in your positioning relative to the subject – but a tripod is very handy when recording with a zoom focused on distant object or player, such as a ball game or car race. Even experienced professionals wouldn't try hand-holding in these situations. A good tripod helps to retain your framing on the subject whilst minimizing camera shake. Invest in a good tripod or even a monopod for such situations and you will see instant improvements.

Jagged edges

Although movie and video cameras offer the facility to take many pictures per second, there can be problems when recording fast movement – especially where still frames or slow motion playback is later required. Analysis of the individual frames that make up a video sequence will reveal a lack of clarity or even a degree of jagginess (also known as staircasing) within each of the frames that make up the sequence. That is due to the way our TV and video sequences are constructed electronically.

Careful use of the zoom lens is required to frame this shot for best effect. Use a tripod, though.

Sometimes, it's neither practical nor advisable to shoot with a tripod, as this shot indicates.

Here is a great shot in which there's lots of action passing the camera lens. Don't be tempted to hosepipe the scene. Stick with a safe, wide shot and let things go by.

Finding the best recording position

Getting good shots of very fast-action sports such as motor-racing or even flying aircarft is something that comes with practice. Many first-time users have a tendency to position themselves at right-angles to action (such as on the racing finish line) so that the subjects travel through the frame in a split second. The better approach is to get positioned such that the line of action is more acute to the camera lens.

Zooming and panning with the action

Sporting actions obviously lend themselves to the use of the zoom control, in addition to an undisputed need to pan left or right with action. However, in the case of many sporting activities, a dependency upon the zoom can create major problems which might result in your losing that once-only shot. When following a ball-game, for instance, it is a good idea to frame on the centre of the action with the zoom lens but not to zoom in and out constantly. Try and set up your tripod's pan & tilt head such that it can support smooth panning shots. That way, you will be able to remain tight on the action while following it smoothly. Your shots and sequences will look a whole lot better, that's a promise.

Hand-holding versus tripod shooting

There are times when it is essential to mount your camcorder on a good tripod to get the best action shots whilst avoiding undue (and distracting) camera shake during recording. However, there are also many situations when shooting with a tripod is either impossible or very difficult. If you are shooting to edit – let's say you are looking to record some great individual shots that can be cut together with a suitably pacy music track – you may actually find that careful hand-held shooting will give you much more flexibility than would the fixed option. Look at a ball game on TV and you will often see a hand-held camera being used on the touchline and which produces decidedly different shots than the fixed cameras. They complement each other, of course, and each has a different feel. It might be that this is what you are looking for.

If that's the case, practice holding the camcorder steadily in a range of different poses. Don't be afraid to hold the cam near the ground and pointing upwards in order to get the dramatic shot of a bike coming over the brow of the hill, or the snowboarder taking flight on the piste. Position the LCD screen to your advantage and use it as a means of manual support. The possibilities are endless – and with the right approach the shots are there for the taking.

Taking shots from boats is best achieved hand-held. At least in this case you can use part of the boat's structure as a body-prop to aid stability for the duration of the shot.

Using camera accessories

As you become more accomplished at shooting video with your camcorder, you will look for ways of improving your technique further. Very quickly, you will discover the need for additional tools that will help you to improve the quality of your work.

For situations where you don't wish to lug around a tripod, a monopod is an invaluable instant aid to stability.

Tripods and monopods

On the previous page, we considered the usefulness of a tripod when shooting faster action sequences as a means of gaining extra stability. However, this isn't confined to sport or action shots; a tripod is a very useful accessory regardless of what you are shooting. Even casual home users own tripods for the simple reason that they come in useful in all kinds of situations – the most obvious being for those shots where you need a stable and steady panorama or lengthy zoom. There are many occasions when the lack of a sturdy camera mount will render a shot or sequence unwatchable, so invest in a tripod wisely – and spend as much as you can afford. You won't regret it.

External microphones

The camcorder's built-in stereo microphone will be acceptable for all general recording situations, but as you become involved in more specialized uses – such as recording people's personal stories or grabbing scripted dialogue – you will quickly identify the shortcomings of many camcorders' internal microphones. It is at this point that you decide to buy an external (plug-in) microphone which will operate on top of or near the camcorder when recording.

If your camcorder doesn't have a microphone jack input, it might have a 'hot accessory shoe' to which an optional mic can be attached. This might be offered by the cam's maker as an optional accessory.

Portable lighting

Another immensely useful accessory is a battery-operated light that can either sit onto the camcorder's accessory shoe (if it has one) or to a bracket attached to the camcorder's tripod screw adaptor on its underside. There are several low-cost lighting units that accept re-chargeable batteries and which will provide ample illumination in darker places where you wish to record. Bear in mind that the power supply will often be limited, so ensure that you either have several spare batteries or that you exercise caution over the amount of time the light is in use. Treat the portable lamp as a back-up source rather than your main supply. Portable lamps can, however, be very useful even outdoors where you seek to 'fill in' the shadows on a person's face when shooting in bright sunlight.

must know
Remember that an artificial light will often deliver tungsten light at roughly 3,200°K (see page 62). If you wish to use it outdoors, you should apply a daylight conversion filter to it to change its colour temperature. Several portable lamp units offer this option.

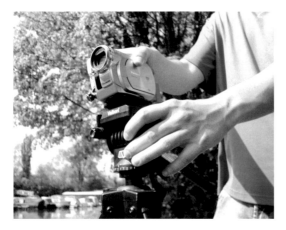

A good tripod is an essential aid to steady shooting, so buy the best you can afford – and learn how to use it to best effect.

Filming children

One of the most common reasons for buying a camcorder is to capture those precious moments of children's lives from the time they are born. Shooting regular sequences of video of the children as they develop is something that will be valued for generations to come, so tackle the job with care.

Try to be relaxed with your children when you are filming and let them become accustomed to having a camera pointing at them from an early age.

Letting the children act naturally

Children are perhaps the least self-conscious of all on-camera participants, especially if they have become accustomed to the camcorder being pointed at them from birth. If this is the case, you have the definite advantage. Even without it, you can capture some wonderful moments that you will look back on with fondness in the years and decades to come.

Where children are concerned, it is really important to let them be themselves. Give them a job to do or an activity to become engaged in that will provide them with a distraction. The more they are occupied with what they are doing the less they will feel imposed upon by the presence of the camcorder. Painting, drawing or another form of acitivity is always a good idea because it increases the opportunity for you to not only observe what they are doing and how they are doing it, but if you are lucky you will be able to prompt them into talking about whatever their thoughts are at the same time.

Don't impose while they're busy

Whilst a child might not feel self-conscious in front of the camera, it's still a good idea not to create distractions by changing settings, moving position,

and so on. Find a comfortable shot, avoid zooming in and out, and record a lengthy sequence that captures as much of the moment as possible. Don't get too close, but remain close enough to be able to properly record every word that is said; this – as you will discover in years to come – will provide you (and the grown-up child) with hours of amusement!

Conversation tips

From behind the camera, ask your child to describe what he or she is doing, and why. Then ask them to talk about their day-to-day life. This will provide future viewers with an interesting insight into life through the eyes of a child, and provide some captivating viewing in later years.

Using an external mic

This is an example of a recording opportunity that requires good quality sound. Unless the room in which you are recording is very quiet indeed, it is worth investing in a good external microphone.

must know

When recording children talking at length, make sure that there is no risk of extraneous noises – such as people talking nearby, doors banging, heavy traffic noise, etc. – spoiling your sound track. You will regret it later if you don't attend to this concern.

Recording the kids at play whilst remaining an observer can often reap significant rewards in terms of the priceless footage there is to be gained.

Shooting holiday movies

The family vacation is one of the key annual events for which a camcorder is a must. If you have yet to buy an appropriate model, now is the time to evaluate your needs, but for existing owners it is time to check that the batteries are charged!

Holiday video checklist

- Camcorder
- Charged battery or batteries
- Battery charger/AC adaptor
- Several videocassettes or disks
- Head-cleaning tape (where appropriate)
- Camcorder user guide
- Flash memory card (for stills, where appropriate)

Optional accessories:
- AV connecting cables (for playback checks, etc.)
- Tripod
- Headphones
- External microphone
- Battery light

Check you have everything

It's not uncommon for holiday-makers to set off for their exotic destination, having packed their luggage, magazines and suncream – only to find that they have forgotten the battery for the camcorder. It has been known for people to pick up the camcorder bag, containing a range of accessories, only to discover later that the camcorder itself hasn't been included! At the risk of stating the obvious, make sure that you check you have all the bits of kit you need well in advance of your departure.

One precaution you can take is to make sure that the camera battery is fully charged. If this hasn't been used for a long time it is also worthwhile charging and discharging a couple of times ahead of

your departure date. NiCad and Li-ion batteries do not like to be left uncharged for lengthy periods of time and will eventually lose their ability to accept a charge at all.

Movie mementoes

People often forget that your movie doesn't have to consist only of video footage. You can employ all manner of holiday mementoes in your project – everything from digital stills pictures to scanned-in images of restaurant menu cards, entertainment venue hand-bills, postcards, and so on. In fact, a really entertaining edited video sequence needn't include any camcorder video at all; a sequence of static pictures accompanied by your favourite music will enthrall your audience just as much! Try it – you'll be surprised at what can be done.

Holidays are a great escape for the whole family, and they also provide you with some lovely mementoes as well, so be sure to grab a wide variety of memorable footage at every opportunity.

There's no more appropriate place to have your camcorder at the ready than when on safari. Grab what you can at every opportunity – but stay safe!

Planning your movie

The fact that you are planning to take your camcorder kit on the family holiday suggests that you have plans for taking lots of footage of your trip. Having ensured that your kit is in one piece and ready for action, it is a good idea to decide exactly what you are going to record and whether you are merely going to shoot the same old holiday movie in a style not dissimilar to the majority of other holiday video recordings out there. Let's be honest. Most people's movies are messy, badly recorded, un-structured and completely uninteresting to watch by anyone who wasn't directly involved in their recording. How can yours be different?

Storytelling in pictures and sounds

Think about what you wish to achieve as the movie-maker before pressing the Record button and – most importantly – consider the needs and expectations of your viewers above all else. Your holiday movie might be intended only for viewing by members of your family and friends, but they are still human beings

who have high expectations, due to many years' experience of viewing broadcast TV. That these people are your intended audience is no excuse for sloppy work – keep in mind the fact that your project is a story-telling exercise in pictures and sounds. If you are telling a story, make sure that it has a beginning, middle and end, and that your viewers understand what they are watching on the screen.

A sense of time and place

Every sequence needs to convey some sense of where we are (in the movie) and why we are there. Use establishing shots and additional detail shots to build up the context, then add all the other fun stuff that we would expect to see in a family holiday movie. So, if you are flying to your holiday destination, take a shot of the airport and give a hint as to your destination by grabbing a shot of either a baggage ticket, airline check-in card or airport terminal check-in board. You don't even have to shoot video – you could use a few still photographs taken with a camera or even hi-res mobile phone! If you plan to edit later, these can be easily included.

Don't be afraid to challenge the rules, especially those relating to shooting with the sun behind you. Here, we're shooting towards the sun with quite dramatic effect.

Recording sports or special events

You might be called upon to make a video recording of a sporting event or a dramatic performance which will be distributed on DVD or even via the web. Whilst it is more difficult to cover larger events with a single camcorder, you will enhance your efforts by taking time to consider your options carefully.

must know

If you are shooting a sporting or dramatic presentation in its entirety, it is almost essential to do so with the camcorder mounted on a good tripod. Not only will this result in greater fluidity and stability, but your neck and back muscles will be in better shape, too!

Finding the best position

Attempting to make a good recording of an event that is, by its very nature, spread out over a large area and containing lots of action in different places is not an easy task, even if you are using more than one camcorder. Trying to record a school sports event or a large stage play all on your own is a near-impossibility, and made all the more difficult by the tendency of other spectators or audience members to get in your way at the critical moment when something spectacular happens. Despite these obvious limitations, there are things that you can do to minimize the problems.

The first thing you can do is to try and recce (*reconnoitre*) the venue before the event itself. It's not always possible, of course, but if you are afforded the opportunity – take it. Once venue managers or event organizers know what you are trying to achieve they will usually be very co-operative, especially if they learn that you are doing it for no profit and for the good of the community! Once you have found an optimum location to record from that gives you not just good sight-lines but also unimpaired sound, you then need to find out what will be happening during the event – and when.

Avoid zooming

There will be times when you do indeed have to zoom in to get a closer view of a piece of the action, but try not to zoom more than is absolutely necessary. If you are recording a concert or music group on a stage and you are recording from a position in the auditorium, you will certainly need to make use of the zoom in order to give your viewers a closer view of the action. A common – and irritating – mistake that is made by many camcorder users is with the zoom in a manner known colloquially as 'tromboning' – that is, zooming in and out almost constantly. It is possible to cover a musical performance, or stadium event, without excessive zooming; when looking into the viewfinder or the LCD screen, keep one eye on the picture and the other on the action. That way, you will be able to

Take care when shooting ball games because any attempt to zoom in whilst the action is heading towards the camera lens will result in your losing control very quickly and a shot that goes in and out of focus.

It is difficult to know where to position the camcorder when recording a theatre or school concert. Here, a central position has been adopted – but take care that bright lighting 'hot spots' don't ruin the image if you are filming in auto mode.

predict with greater accuracy where the camcorder needs to be focused; instead of zooming fully, you can perform a slight creeping zoom combined with a steady pan left or right as required.

Getting good hand-held shots

There will be lots of instances where hand-held shots are much more preferable and practicable than using a tripod, of course. Sports such as biking events, snowboarding and all manner of off-road or so-called 'extreme sports' lend themselves to a more flexible shooting style. Clearly, a tripod will be an encumbrance – although a monopod might still come in handy.

Depending on how you might intend to edit your footage – it could be that you wish to shoot snippets

of exciting action and cut to a suitable music track rather than whole events – you could decide that you need to be able to move quickly from one position to another, and clearly hand-held shots will give you much more creative freedom. Not only that, but you will also acquire a much more diverse range of shots, too. That said, take care to hold the camcorder carefully for the sake of stability.

Shooting good cutaways

There will be numerous occasions during your filming sessions when the camerawork is a bit too shaky or, perhaps, somebody inadvertently knocked the tripod, or whatever. If, when editing the sequence later, you decide to cut this bit out you will be left with what's known as a 'jump-cut' – literally, an unsightly jump in the sequence. Whilst many home movie-makers will be content to leave this in place, you might decide that the finished result needs to be more polished, so you will need a shot – or shots – that effectively paste over the join. It is in this context that a cutaway is required.

A cutaway shot is exactly what the word suggests: we literally cut from the main action to something else – such as a group of spectators watching – associated with the main action. If you hope to create a polished job in editing, you will be grateful that you shot some cutaways. As you gain more experience, you will grab cutaways as a matter of habit – usually recording them in breaks or when something's happening that you don't need in your finished film. Cutaways are a very useful editing device, so always take advantage of any opportunity to acquire as many as you can.

watch out!

In many countries, you must obtain written permission to make and distribute people's performances in any audio-visual medium. If you are recording school events, you will almost certainly be required to obtain written parental clearances before commencing the job.

Recording weddings

As your creative skills with the camcorder improve, you will soon find yourself being asked to shoot a wedding video for a family member or close friend. Lots of people underestimate the difficulties involved in recording weddings properly.

When recording weddings, it's inevitable that the photographer will get in your way. The best solution, therefore, is to include him in the action and create another point of interest.

Capturing the big day on video

Even if you are recording the wedding day as a favour to a close friend or relative, the mere fact that your videotaped record will be the most thorough record of the day is a responsibility that cannot – and should not – be taken lightly. Think of the consequences if your equipment develops a fault and there is nothing to show for it! Apart from the risks involved in not getting it right on the day, it is important to consider why the need for the video exists in the first place.

Obviously, all of those closely involved – not least the happy couple themselves – wish to own a record of the event in years to come. That imposes on you, the video-maker, a requirement to shoot a faithful documentary piece on the chronological events as they unfold – from the early-morning preparations (or even sooner) right through to the ceremony and celebrations that follow. Having accepted the task, you are the one charged with getting it right!

Shooting a documentary

Although there are examples in which video-makers have taken a less conventional approach to the shooting and editing of wedding videos, it is more common for a literal, chronological, record to be made of the event. In this case, your role as a video-

maker is no different from that of a documentary film-maker; you are telling a story and interpreting what you see using your chosen medium of video. The majority of viewers will expect to see events unfold in a given order, so it is important to record the sequence faithfully.

Mixing shooting styles

Most wedding celebrations – irrespective of the religious faith or culture to which they are associated – have key formal moments (such as the exchange of vows) mixed with lighter, less formal intervals. There will be times when you will prefer to shoot hand-held in order to get between people and places for the sake of variety, but for the more staged, formal, moments you will be advised to use a tripod. In Christian churches, for instance, the couple will stand in front of the vicar or priest with the

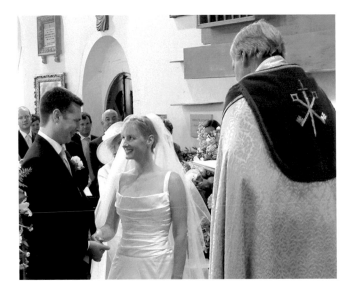

Find the most suitable position from which to shoot the ceremony. In Christian weddings, this will often be facing the couple and behind the priest's left shoulder.

congregation behind them. Clearly, if you are to make a faithful recording, you will need to find a position which favours the couple's faces. If you are unsure about what to do, try and attend the rehearsal and ask the vicar or priest – they will know exactly what's required.

At the end of such proceedings, you will then need to get into a position where you can grab the important shot of the couple walking down the aisle and leaving the building. A quick-release wedge on the tripod and fast leg-work is then required; alternatively, why not set up a second camera to run remotely at the back of the venue?

You will find that such events require quick thinking and a willingness to improvize at short notice. Only with experience will you begin to produce professional-looking and sounding jobs – it's not as easy as it looks!

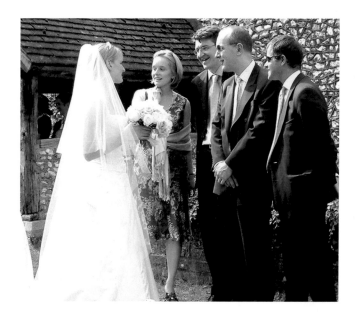

There is more than just the ceremony to record. Grab shots of the post-ceremony socializing in addition to the evening reception and celebrations.

Sounds complicated

Visuals are important at wedding events, of course – they are flamboyant affairs which are the most important days of many people's lives – but so are the sounds associated with the formal aspects and also the celebrations. There is no point recording the official proceedings if your viewers can't hear what's being said. To this end, it is vital that you consider the use of an external microphone – even a small tie-clip microphone positioned inconspicuously close to the couple when exchanging vows – in order to capture clear audio. The camcorder's built-in microphone is unlikely to do the job properly – and you will suffer from lots of background noise if you are shooting from a distance. Of course, if you are using an additional microphone, it is essential to use headphones as well.

Capturing outside activity

Most weddings have a point at which all those present gather outside the venue for photographs and post-ceremony exchanges of conversation. This is a great opportunity for you to gather lots of impromptu and interesting snippets of video to add in to your film. For a start, the wedding stills photographer will take over for quite a lengthy period of time (at least where western, Christian weddings are concerned) and this provides you with ample opportunity to shoot your more insightful material. Don't hesitate to go hand-held and get lots of shots with variety and interest – remember, zoom out wide and get in close for the best shots. Take your time, think about what you are shooting, and remember to concentrate on what you hear, as well!

must know

Are you worried about how you are going to record the important spoken parts without professional-quality radio microphones or long, unsightly, mic cables? Here's an alternative: if you have access to a portable audio recorder – such as a MiniDisc or audio cassette recorder – why not couple a microphone to it and plant the whole thing near the speakers and out of shot? If you are intending to edit the footage in a computer, you will find that the relatively short sequences of vision and separate sound will be easy to synchronize again later. The sound will be clear, as well!

Capturing memories

As your recording techniques improve, you will naturally begin to look around for more serious uses for your equipment and your skills. One extremely useful and engaging activity involves gathering the spoken memories of members of your family, close friends and others in your locality.

Everyone has a story

Video in any form, whether analogue or digital, is an ideal medium for capturing people's personal stories and outlining their family and community history. Thanks to the internet and – in particular – the unquestionable success of websites like Friends Reunited, there is a massive resurgence of interest in genealogy, and with broadband internet connections making it possible to share compressed video sequences online with relative ease, it makes sense to consider how to put your digital camcorder to good use.

The way we used to live

The obvious way to preserve the memories of those around us for generations to come is to record what they have to say. To do that you need a camcorder, a tripod and a personal microphone that can be used to pick up their speech without having to endure lots of background noise as commonly occurs in our homes. Once you have sorted these things out, you have the potential to record what is effectively an interview. Interviews occur when a person provides interesting and informative answers to questions that are posed to them, so it is really important to

ensure that you (or whoever is to undertake the role of the interviewer) ask the right questions. It's no good, for instance, asking a question that is almost certain to elicit the simple answer 'No' or 'Yes'. That's of no use to you at all. Ask open questions that force your interviewee to provide a more rounded, detailed answer – something like 'Can you tell me how you felt when you had to get out of bed and go to the air-raid shelter in the middle of the night during the second world war?' and so on.

Your camcorder has the potential to be an excellent tool for recording the memories of parents and grandparents. Don't miss the opportunity while it still exists.

Recording checklist

Before you make your first interview recording, check that you have done a few important things:

- Ensure that the microphone works and that its battery has power
- Use headphones to check that the sound is being input to the camcorder properly
- If you can't plug the camcorder into AC mains, make sure that you have sufficient charged batteries for the session
- Make sure that you have more tape (or disk) stock than you will need in order to cope with over-runs. You don't want to run out just when it gets interesting!
- Make a test recording and playback with the camcorder BEFORE your recording session.

must know

When you are getting interesting answers to your questions, try not to talk over the person's responses in any way. It's natural for us to utter comments and interjections when listening to others in day-to-day conversation, but try and be aware of this in your recordings – you'll be glad you did when editing it later.

Posed in this way, you be can be sure that you will get a complete answer – and a great piece of video into the bargain.

Picture composition

The way a person is framed in the video picture can have a considerable impact on the effectiveness of the sequence. Watch any TV chat show or current affairs interview and you'll see that the way a person is framed within a camera shot follows a time-honoured convention that dates back to the early 1900s. For your needs, it's advisable to stick with a simple head-and-shoulders composition in which your subject is looking at the interviewer sitting out of camera shot, either to the left or right of the lens. It's not a good idea for the

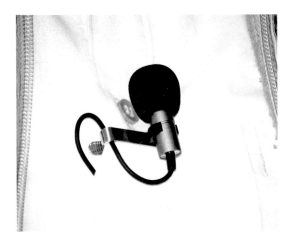

A clip-mic, or tie-clip mic, is so called because of the ease with which it can be attached to either a tie or other item of clothing worn by the person speaking.

person to talk directly into the camcorder lens, unless you are looking for a 'video diary' approach – although even in this case it is not recommended. For instance, the 'diarist' could shoot footage whilst talking about themselves or about what they were filming.

Giving 'looking room'

A key aspect of the age-old framing convention referred to above is what's known as 'looking room'. If your subject is looking to the left, it's advisable to give them some room in the frame to look into. That means positioning them slightly to the right on an imaginary 'third' line in the frame (if you imagine a noughts-and-crosses type grid being superimposed on the picture). It's difficult to explain why this works best – it just does!

If, of course, your interviewee is seated on the right of the camera as opposed to the left, then all the corresponding framing characteristics are reversed from right-left to left-right.

watch out!

When filming people (especially those you know) don't be afraid to get in close. It's common for beginners and even more experienced camcorder users to maintain a safe distance from the subject – with the result that your subject appears less interesting.

Sound recording basics

All too often, sound is treated as the poor relation to the pictures where digital video is concerned, which is a big pity because without good sound the pictures are almost meaningless. With modern camcorders now capable of producing CD-quality sound, why not make full use of it?

Poor sound leads to poor video

It has been observed that audiences will tolerate inferior quality pictures as long as the sound quality is clear, but if the situation is reversed and a film's sound quality is poor, the audience becomes restless. And so it is that many home movie projects suffer simply because camcorder users have given little thought to the requirements of the onboard microphone. This is not only a great pity, but with some careful consideration it is also entirely avoidable.

Today's camcorders feature a built-in stereo microphone, usually of the Electret Condenser type, which is designed to provide clear, adequate stereophonic coverage of the scene being recorded. Whilst acknowledging that most mics of this calibre are not capable of producing stereo sound to a professional level of clarity, they are more than appropriate for the range of uses to which the camcorders themselves are put. However, it is inevitable that without the protection from the elements that is enjoyed by their professional (and very expensive) counterparts, the humble on-board microphone will suffer from handling noise, wind buffetting, and so on. That's why extra care is required.

must know

Be aware that when you are recording in a very quiet room, the camcorder's automatic gain circuits will amplify all the incoming sound in search of something to record. That means that even your handling of the camcorder will be more noticeable, so hold the camcorder firmly and carefully. You could, of course, switch to manual sound recording!

Protecting the microphone

After recording outdoors you will probably have noticed how even a whisper of wind across the front of the camcorder will cause pops and bangs on the sound recording. This is an inevitable by-product of built-in mics; the only way you can avoid this is to try and protect the microphone in the best way possible – or simply avoid recording in windy situations. There are, of course, situations where it might not be an issue – where you wish to take shots which will be accompanied only by music when edited, for example – but at other times you will have to be careful. If your camcorder has a headphone socket, it is advisable to monitor your recordings wherever possible – even if you use only the 'Walkman' type headphones or even iPod ear-buds. Anything that gives you an indication of the sound quality being recorded will help.

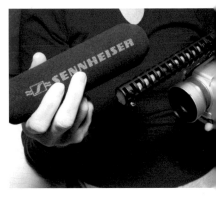

If you are serious about sound quality, you might consider a professional-quality microphone which mounts on the accessory shoe and comes with its own windgag.

Coping with extraneous noises

The quality of sound being recorded by your camcorder will be enhanced considerably if you take time to eradicate as much unnecessary sound as possible. How often have you viewed somebody's home video in which people are talking and misbehaving out of camera shot? Not only is it a distraction to your viewers but it prevents you from doing anything meaningful at a later editing stage. What's even worse is the number of times the person holding the camcorder will be heard to conduct a conversation on an irrelevant topic whilst simultaneously recording! If it's your recording, take control of everything in order to ensure that you get the results you require.

watch out!

If a camcorder is recording in a quiet environment where there is suddenly a burst of sound, its built-in auto circuits will cause significant sound distortion. This can also occur where people are shouting and shrieking near the camcorder. Again, you call the shots, so ask people to be considerate.

Using external microphones

There are times when the camcorder's microphone simply isn't good enough for your requirements, so you have to look around for other solutions. If your camcorder has an external microphone input socket you will be able to use it to good effect.

must know

Unless it's stated that a microphone is stereo, it will almost certainly be mono. The effect of plugging this into the camcorder's stereo mic socket is that the sound source will be reproduced on one channel (usually the left channel) only. This can be corrected if you intend to import your footage into a computer for editing. Alternatively, consider using an adaptor plug.

Getting closer to the sound source

Having established that a camcorder's onboard stereo microphone will invariably capture more sounds than we really desire, it's a good idea to use a more specialized microphone in situations where we wish to narrow down the audible field within our footage. For this, we need to use either a personal microphone which attaches to an item of the speaker's clothing or a directional microphone which may sit on the top of the camcorder.

If you are recording a person speaking in an interview situation, or even if you're making a so-called 'video diary' of the sort that is familiar on TV,

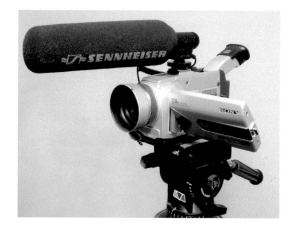

Sometimes the built-in micro-phone on your camcorder is not enough. There is a wide range of bolt-on microphones available.

you will find that the best approach is to use a tie-clip microphone – so called because it clips onto a tie or other item of clothing worn by the person doing the talking. Tie-clips (also referred to as 'lavalier' mics) can also be placed close to the sound source if not attached to clothing. When filming outdoors, it's a good idea to use a foam windshield (also called a 'pop shield') in order to reduce wind noise. Clip mics are also good at concealment in shots where you don't want a mic to be seen – for example, period drama shoots and such like (you might be recording a piece of drama at your school, for example).

Towards more directional sound

For situations where you don't wish to attach a microphone to the person speaking in front of the camera you may instead prefer to mount a microphone with reasonable directional properties on top of the camcorder itself. It could be, for instance, that you are recording some people having a conversation (either scripted or impromptu) or you are shooting a school or religious concert. In this case, you might consider using a specialized directional microphone of the sort that can attach to the accessory shoe on the top of your camcorder and plug in to the cam's microphone socket.

It does, of course, depend upon your camcorder having both the above features. Accessory shoes are fitted to enable the connection of not only microphones but also battery-operated lights. Some are what's called a 'hot shoe' or, alternatively, an 'intelligent shoe'; these have the added ability to transmit power and other functions to the accessory such as a zoom mic or flash light.

watch out!

It's important to remember that when you are recording with an external microphone always to monitor what you're recording with headphones. Given that the external mic jack will cancel out the camcorder's own built-in mic when plugged in, you could end up with no recording at all.

Self-powering microphones

External microphones, such as the popular Sennheiser and Rode enthusiasts' mics, contain their own power supply in the form of internal batteries and have standard accessory shoe fittings, meaning that they will attach to all common camcorders.

Recording your own commentary

There will come a time when the images and sounds of your camcorder footage will be insufficient to give your viewers a sufficient impression of what it is that they're watching, and that's where a spoken commentary comes in useful. There are several ways to go about this task; at its simplest, you might simply take advantage of differential digital audio sampling rates with the camcorder (such as by switching audio to 12-bit audio) which means that you'll be able to add a commentary track that is separate from the audio being picked up by the camcorder's in-built microphone. This, however, is a bit hit-and-miss since it involves your manipulating the tape in the camcorder and risking erasing what you already have.

A better solution is to wait until a later stage, such as when your digital footage has been imported (we call the process 'capturing') into a Windows or Mac computer where it's a relatively easy job to add commentary, also called 'voice-over', tracks.

Writing a simple commentary

Writing a commentary script is neither difficult nor as daunting as you might think. After all, what you're seeking to do is to commit to tape or disk what you'd probably tell Aunt Nellie as she viewed your finished video project anyway. The main exception here is that you have time to consider more carefully what words you wish to use to describe what we're seeing on screen. Remember not to be too literal; if we're looking at a shot of children playing on a beach or having fun on a Disney Park ride, it's more appropriate to describe where you are and the

Before acquiring an external microphone, check whether your camcorder has an input socket for the mic's jack as well as headphones.

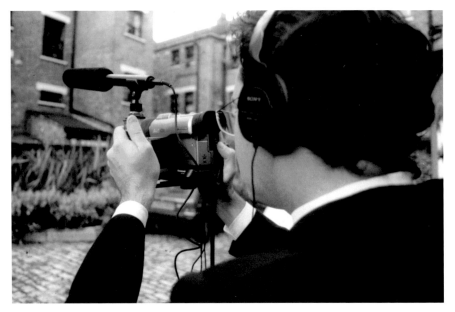

If you're serious about outdoor sound, invest in a good external microphone and a good pair of 'closed cup' headphones.

great time you had over the period of your stay rather than something boring like 'This is little Amy playing in the sand'. We know. We can see what she's doing. So, in mapping out your words on paper, allow the shots to tell much of the story, and jot down words and sentences that complement the shots rather than dominate them.

Recording your commentary

If you're hooked up to a computer and you're using one of a number of popular, low-cost video editing programs, you will find it a relatively simple task to add a spoken commentary to your video project. Simply connect up a microphone to the sound card input, make sure it's at the right recording volume setting and off you go! Alternatively, you might be able to record your commentary direct to tape or disk in the camcorder – or even to an external device such as a Mini Disc or tape cassette recorder.

Taking stills with your camcorder

A high percentage of modern camcorders are in fact all-in-one digital video and stills cameras, making them convenient devices to take with you when travelling or in situations where you don't want to be weighed down with too many devices.

A handy two-in-one device

Trying to shoot video with one hand and take still pictures with another is not easy and nor is it practical, so it's very convenient to have a video camcorder with its own built-in digital stills picture utility as well. The major camcorder makers have provided this feature as an enticement to home users to consider buying what is increasingly referred to as a 'digital media camera'.

Big chips and wasted pixels

To generate digital stills pictures to a high-quality standard, the CCD (the imaging device that turns light into picture elements – or 'pixels') must be of a higher

Sometimes a static yet breathtaking scene such as this one is best served by taking a still photograph rather than video.

resolution than needed for digital video. The traditional rectangular 4:3 aspect ratio TV picture uses a standard-definition picture matrix of 720 x 576 pixels (PAL and SECAM) and 720 x 480 (NTSC), so unless the camcorder is used for additional widescreen shooting functions, this is all that's required of the CCD. Any more pixels in either the horizontal or vertical plane will be wasted. Where a standard PAL 4:3 image will require 414,720 pixels (345,600 in NTSC), this is considered by many users to be inadequate for a good quality digital stills image. Manufacturers tend to install CCDs that can shoot much higher image resolutions – 2,048 x 1,536 pixels (referred to as 3.1 Megapixels) is not unusual and lots of models offer even higher values.

Making best use of memory cards

Camcorders that also shoot stills will have a slot for a memory card onto which the stills can be stored. This will be either an SD card or Memory Stick. The number that can be written to a card will depend upon the card capacity and the image resolution of the pictures.

Transferring stills to a computer

It is common for the contents of your memory card to be exchanged between camcorder and computer using a USB cable. All camcorders and media cameras will have image-transfer and editing software bundled with the product, usually on CD.

Compressed video on a memory card

Lots of camcorders allow small, compressed, email and web format video files to be stored on the card. Usually MPEG1 and MPEG4 type, these can be recorded direct, or copied from tape, and transferred via USB.

Many camcorders have memory card slots which accept either Multi Media or Secure Digital cards.

Working with widescreen

As many home users have now turned their backs on standard TV screen ratios in favour of widescreen TVs – as a means of displaying a new generation of digital 16 x 9 programming – it is natural that camcorder users should wish to record home movies in widescreen as well.

must know

Just because a camcorder is capable of recording true widescreen image does not mean it is recording high definition pictures worthy of the new generation of TV screens. High definition (HD) and standard definition (SD) are two completely different things altogether, each using a vastly different pixel array and method of encoding video pictures for recording.

The spread of widescreen TV

With digital, high-definition, widescreen TV now fast becoming a reality in many countries around the world, it is natural that camcorder users should seek to record their home movies in widescreen, too. The big problem, however, is knowing which camcorders produce 'true' widescreen, and which of those fake the effect with some imaginative trickery.

In the rush to satisfy an apparent demand for widescreen-style images, manufacturers included a filter called 'cinema effect' in their camcorders from the late 1990s onwards. However, this wasn't true widescreen, but merely the effect of electronically chopping off the top and bottom of the image in order to give the impression of a widescreen image (hence the word 'effect'). All it really did was to lose roughly 25 per cent of the resolution due to the user having to zoom into the picture using their widescreen TV's remote handset. Widescreen TVs should be given widescreen images, and there are two ways this is achieved.

What is widescreen?

The term widescreen is used loosely to describe TV and film images that are wider than they are tall by a factor that is greater than the standard 'academy'

1 This image represents a scene shot with the camera set to the traditional 4:3 aspect ratio that we have become accustomed to over the years.

2 Here is what we generally refer to as a 16:9 aspect ratio image, whose appearance we have become familiar with on cinema screens and on widescreen digital TV.

3 In an attempt to include a supposedly attractive selling feature, lots of makers include what they call a 'cinema' effect, which in reality is just a 4:3 picture with the top and bottom shaved off, resulting in a loss of 25 per cent of the image.

4 Here is the result of an image that's been captured by a digital video camcorder whose lens has passed a 'wide' picture which is then electronically squeezed into the CCDs 4:3 space. This is an Anamorphic widescreen effect – the image is unsqueezed at the playback stage.

4:3 ratio. So, whereas a traditional PAL and NTSC picture can be divided into 4 units across by 3 units down (or 12:9) and has a properly-defined technical ratio of 1.33:1, a so-called widescreen picture will have a correct ratio of 1.85:1 (commonly called 'flat widescreen' or 16:9). There is an even higher ratio widescreen, called 2.39:1 'anamorphic widescreen',

but it is associated more with cinema than home video. When we talk about widescreen in the context of camcorders, we usually mean 16:9.

Proper widescreen

Whether or not your camcorder can generate proper 16:9 widescreen images depends on the size of the CCD's pixel array. Proper widescreen requires a wide CCD, pure and simple. When recording in standard 4:3 mode, the camera creates an image from the pixels in the centre of the CCD array, but when you select 16:9 widescreen mode, the camera will then employ pixels on the left and right reaches of the CCD to produce a wider field of view. Unfortunately, only a few camcorders have true widescreen chips (CCDs).

By far the majority of camcorders employ a cheat to achieve a widescreen image display in that they squeeze the wide image entering the lens into the traditional 4:3 CCD space and then rely on a corresponding un-squeezing at the viewing stage – either when the material is viewed on a widescreen TV or when importing the footage into a computer editing program where it is amended accordingly.

What widescreen am I getting?

If, when testing a camcorder, you have the facility to switch between the product's 16:9 mode and the standard 4:3 mode, point the camera at a scene and frame it carefully. Now view the scene, firstly in 4:3 mode – observing the left and right limits of the image. Switch to 16:9 mode; is the field of view now wider, including elements of the picture that are not shown in 4:3 mode? If so, the camcorder is likely to be using additional horizontal pixels to produce the image.

want to know more?
• If you have a digital TV receiver/decoder, compare the effect of widescreen programming with its equivalent 4:3 display.
• Investigate your camcorder's picture settings and experiment with shots in both 4:3 and 16:9 ratio.
• Practice writing and recording simple commentaries and test them on members of your family and friends to gain their reaction.

weblinks
• Visit Wikipedia for technical info on video and audio technical principles at www.wikipedia.org
• Visit the BBC's Family History website for tips on how to capture people's memories on video at www.bbc.co.uk/history/familyhistory

4 Editing home movies

If you are concerned that the process of editing
your camcorder footage will be very complex
and costly, then don't be. Thanks to simple
connections, low-cost computers and highly
accessible software applications, it has never
been easier to import your tape or disk footage
into a computer, tidy it up, add titles and
music before sharing the results with others
on disk, tape or via the web.

What is video editing?

At its simplest, the editing process involves cutting out the unwanted bits and putting your shots into an order that is more enjoyable to watch. However, you will soon see that modern video editing packages provide you with many more exciting possibilities.

must know

When the contents of your digital video tape or disk are copied to the computer's hard disk, the original is not affected in any way. If you make a mess of the clips when editing on the computer, you can always re-transfer the original clips in the worst instance!

Cutting out the unwanted bits

All entry-level video editing packages make the job of cutting out the unwanted bits very easy indeed. Long gone are the days when you had to cue up a video recorder and try (often unsuccessfully) to copy across clips in a precise order whilst running the risk of missing a few words or an important action in the process. Today, almost all new Windows-based and Apple Mac computers have what it takes to capture, edit and export large volumes of home video footage. Once in the computer, thanks in most cases to a type of digital connection known as FireWire, it is very easy to start simple editing with software that comes ready-installed as part of Windows XP or Apple OSX computer operating systems. Trimming bits out of clips is the first, and perhaps easiest, thing you can do in these applications.

Timeline editing

In the same way that your camcorder records clips in sequence, starting from the beginning and progressing towards the end of the tape or disk, so all common computer editing programs make it possible for you to build up clips in sequence right there on the computer screen. Because the video clips now reside on the computer's internal hard disk

drive (HDD), you can change their order, copy them and even delete them at will without ever harming the original footage. What's more, it is here on the Timeline that you can add music, titles and a myriad of transitions and special effects. For the most part, however, beginners are content to simply tidy up what they have prior to making a DVD disk of their efforts or copying to tape.

What computer – Windows or Mac?

These days, it doesn't really matter what computer system you employ for the capture, editing and exporting (sharing) of your home video projects. Modern Windows PCs are powerful enough to undertake the high level of processing required by digital video, although it is likely that a given model

Apple Macintosh computers are all designed with DV editing in mind, and come ready-installed with a great piece of software called iMovie which beginners will have no problem using with no prior experience whatsoever.

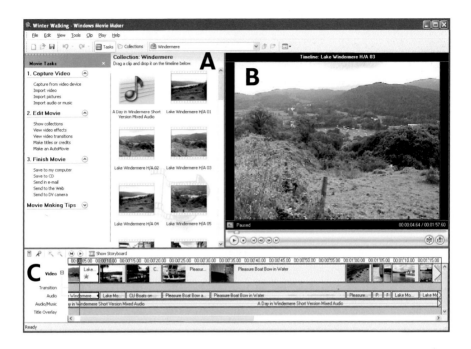

In most video editing software windows, the Clip Bin (also known as the Assets Folder, Collections or Album) will appear in the upper left portion of the screen (A), with the Preview Window situated on the right (B). Most often you will find the Timeline running along the bottom of the screen (C).

might not have the important FireWire (IEE1394) connecting socket required for transfer of digital tape footage from the camcorder to the computer and back. Where DV and Digital8 formats are concerned, FireWire is a must – and not to be confused with USB which will not always do the job as effectively. Not only does FireWire give you a quick, easy connection to a computer that's fast enough to transfer full-specification digital video, but it enables the computer to take over all of the camcorder's controls as you search for and select clips to be transferred. It's worth noting that all Apple Mac computers come with FireWire sockets as standard, in addition to an excellent piece of video software called iMovie that's just perfect for beginners. Windows XP users can freely take advantage of Windows Movie Maker.

Typical editing screen layout

Although there is a wide selection of video editing programs to choose from as a means of getting the job done, you will find that there are great similarities between them. Whether in use on a Windows PC or Apple Mac, all the programs have three essential elements:

- a Clip Bin, where all the camcorder clips are stored in readiness for selection
- a Preview Window, where a clip or group of clips can be played
- a Timeline, where the selected clips are assembled in the desired order

In most cases, the Clip Bin (also known as the Assets Folder, Collections or Album) will appear in the upper left portion of the screen, with the Preview Window situated on the right. It's common for the Timeline to run along the bottom of the screen.

In practice, a clip will be selected in the clip bin and previewed in the appropriate window. If it is considered worthy of inclusion in the project, it will be dragged to the timeline and dropped into place along with other chosen clips. Here, they can be trimmed, re-arranged or deleted from the timeline altogether. It is here that you are given the chance to modify sound levels, add music, special effects, titles and even commentary, as well.

Depending on the editing application in use, you'll find ample resources at your disposal – such as transitions and specialized digital video effects – that will enable you to move your sequences forward in time and place during editing.

watch out!

Camcorder makers include a USB cable with their products, even where FireWire is the preferred method of transfer for DV and Digital8 recording formats. Whilst USB 2.0 is ideal to transfer DVD recordings, and also those saved to memory cards and hard disks, it's better to use FireWire.

Considering high definition

The TV and video formats we have come to know and love have a new name, and it is Standard Definition. It is now about to be pushed aside by a video system that is bigger, better and requires a whole new load of technology – HD or high definition.

must know

HDV camcorders will allow recording and playback of both SD and HD formats – DV, DVCAM (the slightly higher-spec version of DV) and HDV. HDV recording requires a heavy MPEG2 compression, but can still be output as DV from the camcorder via FireWire. Capturing and editing HDV 1080i video to PCs and Macs requires a higher performance all round, although HDV-capable editing software is readily available on both computer systems.

Move over SD

High definition television has been talked about and planned for by the TV industry since the late 1980s, but only recently have we seen the introduction of a consumer video format that is poised to revolutionize not only the way we view video on a TV but also the way in which we shoot it. The year 2005 was the year that Sony introduced the first HDV (high definition video) camcorder, and we have not looked back since.

HDV is so named partly because it manages to write a much higher resolution video picture to a standard DV cassette (albeit with a slightly different surface formulation). In contrast to SD (standard definition) video, which is based around either a 720 x 576 pixels (4:3 ratio, PAL) or 720 x 480 pixels (4:3 ratio, NTSC) picture, HD offers a much wider picture which consists of many more horizontal lines. In order to achieve such a high quality recording on very compact recording media, some clever electronic solutions have been employed.

The big picture

The most obvious advantage that HD has over SD is the much bigger picture. You can see from the illustration on the opposite page just how much more screen area is provided by the 1920 x 1080 image. Even

the lesser-resolution 1280 x 720 image is considerably bigger than our standard 4:3 ratio TV pictures, and this is something that current HDV camcorder users are keen to exploit; it really does open up tremendous creative possibilities if used wisely.

Progressive and interlaced

The camcorder manufacturers offer two modes of shooting with HDV camcorders. The first is the 'p' (progressive) mode, with the other being the 'i' (interlaced) mode. Interlaced HDV, as offered by the pictures that consist of 1080 lines (1080i), works in the same way as a standard interlaced video picture by creating a video image with alternate interlaced scanning lines. Progressive scanning, as applied to the 1280 x 720 image format, known as 720p, combines the two fields together to produce a single frame. This is considered by many serious users to offer a smoother, more film-like image sequence.

Although the composition of these two images remains identical, their relative sizes is an indication of just how much larger the HDTV picture is - 1920 pixels wide as opposed to the conventional Standard Definition 1024 pixels widescreen image. The result is greatly improved picture clarity on similar-sized HDTV capable displays.

From camcorder to computer

The first step to editing and sharing your video projects is by transferring your sequences from the tape or disk into the computer and onto hard disk. Where digital tape is concerned, this is called 'capturing'.

must know

Standard definition MiniDV or Digital8 video recordings require approximately 13GB (Gigabytes) of computer hard disk space per hour of footage. If you wish to store your video in a single continuous stream you will need to ensure that your Windows PC's hard drive is formatted for NTFS rather than FAT32. If in doubt, consult your computer manual.

Using FireWire to capture footage

We have already made reference to FireWire and how it plays a pivotal role in the accurate transfer of your digital video tape recordings from the camcorder to the computer as you prepare to edit and share your project with others. FireWire is a simple means of digital signal connection that is provided with all MiniDV, HDV and Digital8 format camcorders and (as it happens) with every Apple Mac computer. FireWire, or to give it its proper label 'IEEE1394', comes in two forms – a small 4-pin connector as found at the camcorder end and also on some computers, and the larger 6-pin variant that exists on computers (including Apple) and many peripheral devices that can be attached to computers. It's often the case that you need a 4-pin to 6-pin cable to facilitate capture of footage from camcorder to computer.

Device control, as well!

The FireWire cable not only passes the digital video and audio signals in either direction but also the instructions that are sent by a computer to a camcorder (or DV recorder) in order to control its playback and recording functions before and during transfer. Using a suitable video capture and editing program on the computer (such as Microsoft

MovieMaker or Pinnacle Studio on a PC, or Apple iMovie on a Mac), it is now possible to capture either all or selected clips to a folder on your computer's hard disk. If your camcorder allows edited sequences to be recorded back to the tape inside it, then FireWire will also enable this process to be managed from within the computer.

Selecting individual sequences

All programs will give you the freedom to simply capture the whole tape's contents to the hard disk or manually work through the tape in the camcorder and select only those sequences that you wish to capture for editing. It might be, for instance, that you only require a range of shots relating to the task in hand whereas the tape itself contains a lot of irrelevant material. This technique is also preferable if the hard disk space on your computer is limited.

watch out!

It is easy to confuse a FireWire cable for a USB cable and to assume that this can be used to transfer DV and Digital8 video footage to computer at full specification, simply because manufacturers enclose USB cables with camcorder kits. However, it is better to use a FireWire cable all of the time.

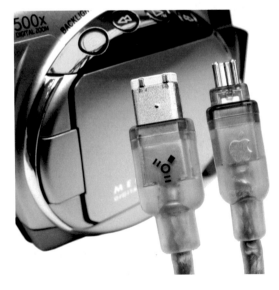

Here is an example of a FireWire cable that is most commonly used to connect a DV or Digital8 format camcorder to a Windows PC or Apple Mac computer to transfer video across during the capture process. Note that it has a 6-pin (left) and a 4-pin (right) connector.

Importing from disks and cards

As we shift away from buying camcorders that use tape and into a domain in which our video clips are stored on DVD disks and memory cards, so the manner in which they are imported in computers will change dramatically. Already, we are able to copy clips to a computer in the same way that we transfer our still images.

must know

DVD camcorders don't use the same size disks that are used in domestic DVD player/recorders and other standalone devices. They use 8cm disks, which are 2cm smaller than standard DVDs, although all disk drives will accept them providing they are inserted into the drive carefully.

Random access to digital video clips

Manufacturers and resellers are seeing a steady and rapid shift away from the sale of tape-based camcorder formats like MiniDV and Digital8 in favour of those that use disks and solid-state memory cards, and it is not surprising to see an increasingly wide choice of models now available. Given that many people buy a digital stills camera in order to take their family photographs and download them quickly to their computer, it is natural that many of us should seek to download our digital video clips from camcorder to computer in the same manner. With tapeless systems, this is indeed possible. The clips are saved to the disk or card in exactly the same way as are digital still pictures, so it is easy to browse for a previously-recorded clip, click on its thumbnail icon and play it there and then in the camcorder. What's more - if you don't wish to retain it, simply delete it!

Editing and playlisting in camera

Many of us are now accustomed to downloading music files to an iPod or other portable MP3 playing device and listening to music that we have arranged into playlists. If you are an owner of such a device, you will know that you can create and manage your

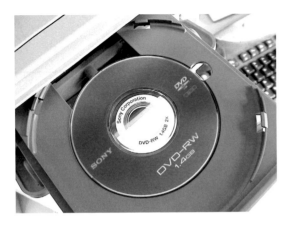

Movies from DVD camcorders can be imported simply by placing the 8cm disk into your computer's DVD drive. Even though they are smaller than normal disks, the computer will be able to recognize and read them properly.

lists in your computer, using a program like Apple's iTunes, and transfer your tracks to your MP3 player via either a USB or FireWire cable, where you can then listen to tracks in any order. The principle for digital video that has been recorded to DVD or solid-state media is exactly the same; your clips are imported into the computer, re-arranged, deleted as required and saved. When you are happy with the results, you are free to export the final project to DVD, a portable media player – such as a Playstation Portable or iPod Video – or upload to your webspace and made available in a compressed form for family members, friends and colleagues to see via their internet connection. It's all becoming very easy.

Importing clips from DVD disks

There are two ways in which the clips recorded with a DVD camcorder can be imported to your computer. The first method is to connect the camcorder to the computer using the supplied USB cable (noting the different type of plug at each end) and then use the software supplied on CD or DVD that will enable you

watch out!

Your standalone or set-top DVD player might not recognize the disk that has been recorded in your DVD camcorder. It could simply be that it is a DVD-RW format disk that first needs to be finalized in the camcorder. Check your DVD player's user manual for guidance.

Capty MPEG is a program for use with Apple Mac computers that helps you to connect with SD cardcams and other tapeless formats in order to transfer their MPEG2 clips and edit them. It can also convert files to make them readable by iMovie.

to import the video files from the disk to the computer and edit them as you wish. If, on the other hand, you have a DVD drive (as, thankfully, the majority of new computers now possess), it is a simple job of inserting the recorded DVD disk into the drive slot and using the supplied software to extract the files to the computer prior to editing and exporting to your chosen medium.

About MPEG2

It is important to understand the fundamental difference between the type of file that is created from DV and Digital8 videocassettes and those

Pinnacle's Studio Plus program makes it easy to import titles direct from a DVD disk regardless of its size. Simply select Import DVD Titles from the menu and select the individual clips to be imported into the Clip Album.

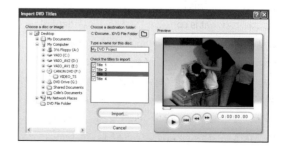

which are generated by DVD, Solid-State and Hard Disk recording camcorders. Camcorders that make recordings in the DV format (the recordings on Digital8 are effectively DV recordings, as well, by the way) are creating a stream which, though subject to some compression at a factor of 5:1, are generally considered to be the base level format for consumer video, and it is against the DV 'standard' that other formats are compared when considering matters such as compression. When the contents of your DV tape are transferred to your Windows PC or Apple Mac using a FireWire cable, they are said to be 'captured' to the computer's hard disk. In doing so, the computer will enclose the incoming stream of data into what is called a 'file wrapper'; in the case of Windows PCs, this results in a .AVI file format. With Apple Mac computers it's a .MOV file, although this will sometimes show as being a 'DV Stream'.

In order to create a DVD disk containing your camcorder movies, however, you will need to change the edited project files into something that all DVD players can understand. That's called MPEG2 – a file format that is the result of heavy compression of the information in the computer in order that the DVD disk can accommodate it. The reason why a single disk can hold a lengthy video recording is solely due to compression. This involves a complex process of discarding what is considered to be 'redundant' data and processing only the changes within a given sequence (called a GOP, or Group of Pictures). So, if your frame contains a person seen moving in front of a static background, the MPEG2 processor will allocate most of its resources to handling the changing part of the scene and forget about those bits that are static.

must know

Having a choice of quality settings on a DVD, SD or HDD camcorder will allow you to cram lengthier recordings onto them, but this will entail higher levels of compression – and more compression equals less quality, so consider your options carefully.

Detecting clips automatically

When capturing or importing video clips to your computer, your editing program will produce small thumbnail images representing every new clip, which are automatically generated as they enter the computer. This is called Automatic Scene Detection.

Recognizing clips by thumbnails

Every time you record a new sequence in your camcorder, the device will embed information relating to the timecode (if recording to tape) as well as the date and time of the recording itself. In the case of tapeless camcorders, the system will generate a clip number and other so-called meta data relating to the saved file. All this information has a variety of uses later. The most common use of timecode, date and time 'stamps' on DV tape formats is that it enables both the camcorder and computer to figure out not only when the clip was recorded and where it is on the tape, but it means that a computer capture (and editing) program will be able to divide up the whole tape into unique clips. Thanks to Scene Detection, the resulting thumbnail images that are created every time a new clip was recorded will assist you in logging and selecting clips within the editing program.

Renaming clips

Having captured a whole sequence of video clips to the computer, you will discover that the program generates a default – and sequential – set of clip names. In Microsoft Movie Maker, this relates to the date and time that the clip was recorded (which at least guarantees uniqueness), whereas Apple's iMovie

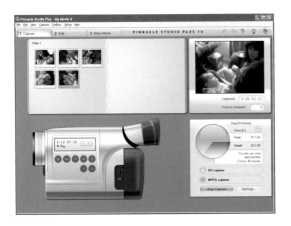

Note the way that a new thumbnail icon is created by the program to represent each new clip as it is captured from the DV tape in the camcorder. The way different programs label each clip will vary from that used here by Pinnacle Studio Plus, but the principle remains generally the same from one software to another.

watch out!

If, when recording to tape, you allowed the timecode numbers to reset to Zero, you will now have a tape with two or more sets of 0:00:00:00 digits. This could cause problems if ever you wish to upgrade to professional programs, as the timecode on the tape ceases to be unique.

and Pinnacle Studio produce a clip number starting from '1'. Renaming a clip to something that reminds you is easy; you may wish to provide a simple description of the scene – such as 'Holiday_01' – or some other descriptive text that fits your need. Whatever your preference, using a personalized naming convention will help you search for clips and, of course, it will save you the effort of inspecting every clip manually to remind yourself of the content. The existence of a thumbnail image showing you the first frame of each clip is an additional aid to clip selection.

Deleting unwanted clips

There will undoubtedly be instances where the camcorder was recording when it should not have been, or where you have simply shot too much material and have no intention of using it. Deleting a clip from the tray, or 'bin' as it's called, is easy; simply click on the clip's thumbnail icon once to highlight it and then hit the delete key. Alternatively, right-click the mouse (in Windows and most Apple Mac applications) and select Delete from the menu option.

The editing timeline

With the clips now stored on your computer's hard disk, the job of assembling them into a sequence could not be easier – and it is something that anybody can do. The timeline is where all the action takes place.

Introducing timeline editing

The timeline is exactly what it implies – a line along which we assemble a set of clips from left to right, starting at zero and progressing to the last of our chosen clips at the end of the movie. Given that a selection of clips that have either been captured from tape or imported from a DVD or solid-state camcorder now reside in the clip bin where they can be previewed, we are now free to experiment with the construction of a simple sequence on the timeline. To do this, simply select any clip by clicking on it once and holding down the mouse as the clip is dragged and dropped onto the blank timeline. It will automatically be placed at the beginning. Now repeat the exercise – dropping the clip after the first. Now you have a sequence. That's how easy it is! Play the sequence (perhaps by placing the Cursor – also known as the timeline scrubbing tool – at the beginning and clicking the Play button).

Changing the order of clips

Having placed a few clips onto the timeline, it's just as easy to change their order. Simply drag a clip from one location to another. You will find that the clips that exist behind the point at which you need to insert your selected clip will automatically move

Many editing programs offer two timeline viewing modes. Here, Microsoft's Movie Maker is set to its default mode in which picture and audio tracks are clearly visible, and with its display being representative of the clip's duration.

along in sequence. This can be done with either a single clip or with a group of clips; in the case of the latter, simply use the standard keyboard combination (for instance, Shift+Click or Ctrl+Click in Windows, depending on whether you want to move a single group of a collection if individual clips) and re-arrange accordingly. You can now play the whole new sequence by using the 'Return to beginning of timeline' button (see the user guide for details or hover your mouse over the player controls for a popup description) and selecting Play. Don't forget to save your project regularly, too!

Trimming individual clips

Although it is likely that you will place a clip on the timeline before deciding to shorten it – either by dragging its beginning or end 'handles' – you don't have to place clips on the timeline in order to trim them down. All commonly-used applications will provide the means to slice off a part of the clip or chop it up into smaller sub-clips.

In contrast to Movie Maker, Apple's iMovie offers a Storyboard view by default. However, it is easy to switch to a more detailed view as required.

Constructing video sequences

In one sense, video editing involves cutting out the unwanted bits and re-arranging those that survive. However, as you become more experienced, you will find that there is actually much more to it than that. Editing engages you in a satisfying process of construction that can reap its own rewards.

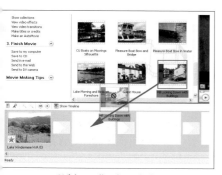

With a collection of clips now at your disposal, you can begin to assemble your first sequence on the timeline. It's as easy as clicking on your chosen clip, dragging to the timeline storyboard and dropping it into place.

Arranging shots into sequences

As soon as you put two shots together on a timeline you have the beginnings of a unique movie project. Add a third and fourth and you are well on your way to something that has the potential to excite and enthrall those who get to see the finished result. Why? Because although we may take lots of individual shots with our camcorders, the result is never a movie until you have spent some time thinking about how they should be trimmed and arranged. Good video editing is about building sequences that take your viewers from one place to another, after all.

It is important, therefore, to consider what role a particular shot is taking when being placed on the timeline. It is understandable that a wide shot of your vacation resort will be placed at the beginning; this provides us with the establishing shot we have discussed previously, and it is a convenient way to give people an idea of where we will be in the following sequence. Assembling other sequences in a way that provides structure to the movie is a logical step, otherwise the whole thing will appear disjointed. Tell a story in vision and sound – and test it on others if necessary.

If it doesn't add anything, drop it

As your confidence increases with more practice, you will find yourself being less precious about your raw footage. The shot that we like simply because it was there might not actually contribute much to your finished project. There will be times when your viewers will ask 'What's that?' which is really a cue for you to discard it altogether. The basic rule of thumb is that if a shot, or group of shots, doesn't earn its keep then it might as well be dropped altogether. It is something that happens every day in the professional film and TV markets – a shot that cost a lot to shoot will be dropped if it does not work, pure and simple. It is a good frame of mind to get into, and it will also prompt you to think more carefully about what you are shooting, as well.

Recording more than you need to

One thing you learn when you show your raw footage to family and friends is that you have probably shot much more than you needed to in any one situation, to the point where viewers start getting distracted. The editing process not only gives you a perfect opportunity to trim this back and resume control over your work before it's shown to others, but it also acts as a stark reminder that you have been over-shooting every time the Record button is pressed. So, when you are aiming the camera at a scene, take a deep breath, start to record, count to three slowly, and – if your shot has already achieved its purpose – stop. Obviously, if there is action within the frame that is ongoing, then you may wish to stick with it, but even then you have plenty of opportunity to shoot in such a way as to make editing easier at the later stage.

must know

If you are taking a static shot, such as an establisher, it is a good idea to frame the shot before recording. Once you are happy, press the Record button, holding the camcorder still for 3 seconds. If you plan to zoom or pan, then do so carefully – and when you stop, keep the camcorder running for another couple of seconds. Now you have something you can edit properly.

When shooting footage of family and friends, give some thought to how it might be edited later.

Using video transitions

As you view the raw footage that was taken with your camcorder, you will be presented with straight cuts between one shot and the next. However, once your clips are in a computer you can spice up your project by adding video transitions to your sequences.

Simple transitions you see every day

Watch any feature film, commercial or TV show and you will see that whilst simple cuts are the primary means of taking the viewer from one shot to the next, there are times when other forms of transition are used. The first and most obvious non-cut transition is the fade in and fade out, in which the picture either starts with black and fades in the incoming visual, or vice versa. If you pile a 'fade in' on top of a 'fade out' you get a mix of the two, commonly called a dissolve or cross-fade, and that's the next most commonly used transition, of which there are too many to list.

Getting from A to B

The use of a transition in a sequence or, more importantly, between edited sequences, has the effect of moving the viewer on from one stage or place and into another new one. It could be that we are coming to the end of a sequence shot at the airport as we prepare to fly, and in the next sequence the viewer will be transported to our holiday destination – having cut out the whole journey from the video. The dissolve transition takes us from one place to another gently; your viewers will understand this instinctively.

The set of transitions offered by all entry-level editing programs is reasonably standard. In Movie Maker, just select 'Edit Movie > View Video Transitions' from the left menu, then drag the chosen transition to its position between two clips. You then view it in the Preview window on the right.

Another use for the dissolve might be in a sequence of gentle, slow-moving shots where cuts between them might be considered too harsh. Gentle crossfades might be more appropriate. How you use a given transition is down to your own preference – but do not overuse them, and don't attempt inappropriate transitions either. Gimmicky transitions will give an amateurish feel to your production.

watch out!

Some programs require that video transitions and effects are rendered as soon as they are applied to the timeline. This occurs in the background and does not stop you from doing other things, but it might slow functionality down for a short while as it goes to work.

Applying transitions between clips

Although the manner in which they are displayed will differ depending on the video editing program being used, the principle of available transitions being presented to you as icons in a window where they can be previewed, and from which they can be dragged and dropped between clips on the timeline, is fairly consistent. Very often, the window displaying the Transitions will share that of other facilities and also your media clips (such as video, audio and images). In all cases, you will be able to test the result of applying a transition before

Movie Maker's set offers more than just the basic options, such as this special 'glass shatter' effect designed to take the viewer dramatically from one shot or scene to another.

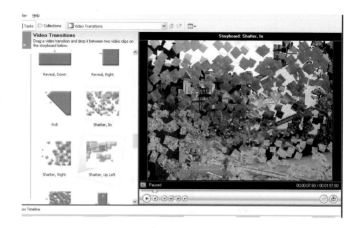

actually applying it, and even after its application you can easily modify or move it, or replace it altogether. The range of transitions available to you will vary from program to program, although all of the basic two-dimensional ones will be evident in all programs.

Basic transition families

Video transitions are generally grouped into three families – fades, wipes and 2D/3D variants. The first category is fairly explanatory, and consists mainly of fade-ins and dissolves. Wipes, on the other hand, are those transitions which change from one image to the next by way of a vertical or horizontal line (or combination of the two) which moves to reveal the new picture; this includes various geometric shapes such as boxes, circles and stars, for instance. The last category covers a huge multitude of visual moves, and is too complex to describe easily, though you will no doubt want to play with the many multiple-effect transitions available to you that result in highly complex moves between shots and sequences being achieved.

Transitions that complement

Like in-camera digital effects, it is common for beginners to

attempt to use as many eye-catching visual gimmicks as possible, and whilst there is absolutely no reason why you should not seek to experiment with your new toys, you will soon get to a stage where you will have observed just how little such tools are applied in the feature films and TV shows that you see on a daily basis. The truth is that the less you use transitions the greater effect each one has when viewed. So, try inserting a simple fade-out, followed by a fade-in, between two sequences. Alternatively, consider using a dissolve or circular wipe. For most ordinary, uncomplicated home video sequences you will find this to be all that you need, and anything more fanciful or complex will not add anything meaningful to your home video efforts at all.

Obviously, there will be occasions when you are creating a sequence that has a lot more pizzazz about it; for example, you might have shot footage at a party where there is lots of music playing and people dancing. In a case like this, you will find it good fun to throw in a few 2D or even 3D transitions that help the visual and aural context of your movie.

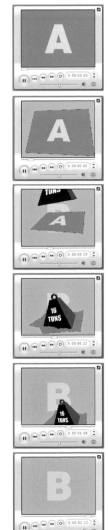

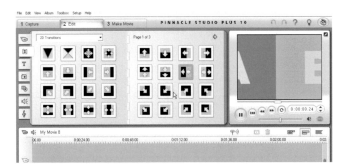

Above: Pinnacle Studio Plus has a very similar transitions menu layout. By clicking on a transition icon in what Pinnacle calls the Album, you will be shown an animated representation in the Preview Window on the right.

Above, right: There are many possible uses for 3D transitions that get the viewer from A to B. Here, the outgoing clip is represented by the letter A, with the incoming represented by B in Pinnacle Studio's preview window. This is a useful means by which to sample the transition before its application on the timeline.

Video effects and filters

You can change the way a clip appears on screen with the same ease as you can apply a transition between clips. With most editing programs you can not only make modifications to colour, brightness and contrast but add a host of other weird effects as well.

Improving the look of a clip

There will be times when you have recorded a clip only to realize later that it is darker than you would like it to be, or you might decide to alter its colour or contrast to make it more consistent with the clips either side of it on the timeline. For this, you need a set of tools designed to enable you to modify a clip's visual properties – known as 'grading'. All video editing programs have a set of functions designed for this; usually you will click once to select a clip (or clips) and then drop the desired effect thumbnail onto it to open up the relevant control panel. In Apple iMovie, the effects options are displayed in a window on the right of the screen and are represented in list form from where they can be selected and previewed.

Here's quite a common effect which mimics a watercolour brush effect on a sequence of moving images. Used carefully - such as in an opening or title sequence - it can have a dramatic effect.

Even your best, highest resolution, colour video footage can be adapted to represented the period in the video itself. Here, we've applied an Old Movie filter to give it a suitable look. You can even apply film scratches to make it look authentic.

Simple dramatic effects

It might be that you are involved in making a short mystery movie for fun, and you wish to remove all colour in order to give the clips a 1940s black & white movie feel. No problem. Almost all programs provide filters that will not only remove colour, but you can also simulate film scratches in addition to grain and a high-contrast look. Simply apply the effect or filter and you are there. If, of course, you don't like the result, then you will have the freedom to click the Undo button to restore back to where you started. In many instances it is possible to pile effects on top of each other for maximum creative impact, although this will vary from program to program.

Complex special effects

You might prefer to apply some weird and crazy effects to your clips, and although it's likely that some of those available can be undertaken at the time of recording in your camcorder, it is much better to leave everything to the editing stage on the computer. You might wish to apply a posterize or

This effect is called Radial Blur and looks particularly impressive when there's constant motion within the frame. Playpark activity and effects of this sort are a good combination!

emboss filter to fast-moving shots, for instance, or even combine a strobe effect with them as well. The options are almost limitless – all it requires is the right material to which to apply them and a few good ideas on your part. The good thing about it is that you always have your original clips to revert back to should you decide you don't want to retain the changes you've made.

Motion control

Another effect that people find useful is the one that provides the ability to slow down or speed up a clip. We're all familiar with these effects, and have seen them in use in films and on TV countless times, but sometimes they will have their uses in less-than-obvious ways, too. Sometimes you will need to adjust the speed of a clip very slightly in order to make it fit a gap in the timeline whose duration is precise and fixed; other times you might decide that a sequence containing a combination of slow motion and dissolves will work a treat when accompanied by a suitably atmospheric music – the scene in which the Olympic athletes are running along the beach in *Chariots of Fire* is the most obvious example, though there are countless others.

The method for making speed adjustments vary considerably according the program; in many Windows-based programs it is simply a filter that is applied to the clip, and once in place it will open up a control panel allowing manual adjustments to be made. Apple's iMovie, on the other hand, has a speed adjuster which resides at the bottom of the editing screen and can be accessed at any time. Simply slide the speed bar in one direction or another to decrease or increase as desired.

Keep saving

When experimenting with effects and transitions, save your project regularly so that you have a recent file to revert to should you feel that you have gone too far, or if the computer should crash. Another thing to bear in mind is that you can create more than one version of your edited project – simply select 'Save As' and give the current version a new name. All you are doing is creating and saving a different edit list – the clips are not affected in any way, and remain unchanged. Now you can choose which version you wish to show people – the short version or the full version, for instance!

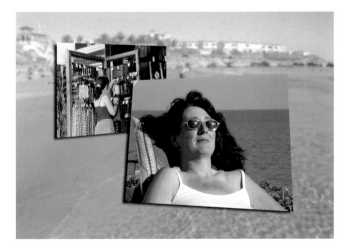

The more elaborate video editing programs give you an added level of sophistication and control. We've thrown the background image out of focus and floated two moving images over the top, along with drop-shadows. Great for a holiday movie intro sequence!

Chroma-key and picture-in-picture

When you are thinking about using more specialized picture effects like chroma-key and picture-in-picture, you are starting to work at a more advanced level. Although these effects are easy to apply, they do need some careful planning when recording the original video footage.

In Pinnacle Studio Plus, chroma key, or green screen, is achieved by placing the green screen shot on the second timeline track so that it will appear on top of the base track above. To achieve this, we have to make some precise adjustments. It's possible to use green screen and p-i-p in combination.

Inserting background action

Chroma-key is a technical term for the substitution of another video picture source into a consistent colour backdrop which sits behind, for instance, a person speaking to the camera or acting. We see the result of a chroma key composite all the time when we see TV weather presenters appearing to stand in front of a weather map, or when we see films with lots of special effects in which actors and models appear to stand in scenes that have been computer-generated. The description 'chroma-key' means, quite literally, the substitution (or 'keying') of one piece of source video for another and which replaces only that colour (the 'chroma') which is designated to be replaced.

So, put simply, if a person stands in front of a green screen, we can tell the software to replace the green colour with other video footage. In years gone by this was a complex and potentially expensive process to achieve, but these days it is easy and cheap to achieve right there on your computer.

Using video overlay tracks

Since you are effectively working with two video clips which are to be fused together as one in your

finished video, you will usually need to use an editing program that facilitates two-track (or even multiple-track) working on the timeline. Pinnacle Studio Plus is one such application that contains everything you need to achieve chroma key (also known as CSO or Colour Substitution Overlay) effects – right down to a few demo clips designed to get you started right away.

You will start with the main subject of the video – let's assume it is a person talking to the camera – appearing in front of an evenly-lit green screen. It doesn't have to be green, of course; it can be any bold colour, although blue is the favoured alternative. Providing that the colour is well-saturated and evenly lit it will suffice, but make sure that the person in the picture isn't wearing clothing of the same colour otherwise the effect will be ruined! Once you have both the chroma-key 'foreground' clip (the one containing the green-screen background) and the clip intended to

1 With the green-screen backdrop evenly lit and the camcorder's control set to manual exposure, we record our star performer as he does his turn.

2 Next, we choose some background video or a still picture. A low-cost editing program will enable us to replace the green areas of the foreground shot.

provide the background action in your clip-bin, drag the background clip to the timeline, and then drag the green-screen clip to the overlay track such that the two are parallel on the timeline.

Making the chroma-key effect work

With the two clips in place, it is now just a question of invoking the appropriate picture processing features as provided by the program. Pinnacle Studio Plus enables you to open a sub-menu in the video effects section and literally tweak the substitution until it is just right. It is also easy to practice this with the clips that are bundled with the software. With it, you will be able to place a female 'talking head' shot over any other video clip that resides on your hard disk (after being imported into the current project, of course). Even then, Pinnacle provides a whole set of demo clips – in this case the so-called 'Clown' sequence – designed to enable you to get going quickly and easily. Notice, also, that the composite of the two shots and the chroma-key effect itself will automatically start to render as soon as they applied.

Pictures within moving pictures

Another visual effect that you might wish to experiment with is the picture-in-picture effect. Again, you will have seen this often on TV – particularly in news bulletins in which a remote reporter appears in a box over the main news anchor's shoulder – and it is something that you can easily replicate.

Using the same software as we did for the chroma-key experiment – Pinnacle Studio Plus – it's a straightforward job to combine the two selected clips in order to insert one of them inside the other. Pinnacle provides an effects filter specifically for this job, and with it you can not only position the box at various locations on the screen but it can be resized, have colour borders added and even drop-shadows applied to it. If you are really clever, you will be able to figure out a method of not only placing a person inside the P-i-P window who appears to have a conversation with himself or herself in the other image, but the whole thing appears as a chroma-key background to another sequence. Try it for yourself!

3 Here you see the result of the combining process. It looks as if our artist is performing his routine on an exotic beach when in fact he was still at home!

Creating titles and captions

Even the simplest edited video benefits from a main title and end caption, and this is something you can easily achieve in all editing programs. But beware – don't be tempted to use overly-decorative or inappropriate lettering styles or you will ruin the effect.

Applying a title to your video

It's funny how people will be more inspired to watch a home video if it has a title at the beginning. Even a simple 'Our Vacation' or 'John and Julie's Wedding' will elicit favourable comments – and that's before the movie has started proper! Somehow, a nicely-created title adds an air of professionalism to the project, although it will also heighten people's expectations of the production quality contained therein. These days, the titles-generation that come either with or part of an editing program will

Many entry-level video programs use a fairly standard interface for the creation of titles and captions. Pinnacle's Title Deko, which is built-in to many of its editing applications, has a clear and easy-to-use menu system.

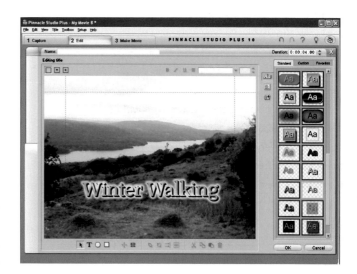

invariably draw from the typefaces (or fonts) that already reside on the host computer and which will also be used when typing documents in Microsoft Word or whatever.

Choosing an appropriate typeface

The importance of the choice of typeface cannot be overstated. A face that is too fancy, and which has bright colours and styles applied to it, will make the movie look cheap and amateurish even before it plays to your audience. Have a look at the majority of TV and films and you will see that – in the main – titles often use simple serif or sans-serif fonts and are plain white (or slightly off-white, for technical reasons). Given the limitations of PAL and NTSC video displays, it is not a good idea to use small type that contains too many fiddly bits that might appear attractive when printed to paper, but when viewed on regular TV screens the fine details will, at best, appear to shimmer with little definition and, at worst, disappear altogether.

Most of the time it is a good idea to use a common typeface like Times New Roman, Palatino, Helvetica or Arial. The first two are what's known as 'serif' faces, containing bits that appear as 'tails'; on the other hand, sans-serif literally means 'without serif', and these are the straighter, more hard-edged faces we see everyday in print, on posters and even on the web. The choice of typeface can directly influence the mood of the piece, so consider their application carefully. Often, the less is more principle is one worth following – and avoid mixing lots of bright, gaudy colours! Not only do you risk technical problems later, but to do so makes the result look horrible.

watch out!

Don't place lettering too close to the edges or the screen or corners of the frame. Even though the title might look fine on the computer's preview screen, it will look completely different when shown on a regular TV screen due to 'safe-area cutoff', which crops into a picture.

It would be inappropriate to spoil the image by placing the title in the centre of the frame and masking the setting sun, so in this case the title has been set into the lower third of the image.

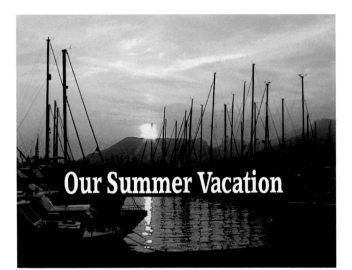

Captions and name-straps

Sometimes you will want to add a simple caption which informs your viewers of the location featured in the shot, or perhaps you want to display the name of somebody performing in front of the camera. In such cases, it is a good idea to create a simple caption designed to be superimposed over the shot and appearing in the lower third of the picture.

You will be familiar with what the broadcast people call a 'name strap' – a coloured or graduated graphic band that runs across the bottom of the screen, over which is typed the name of the person speaking and his or her job description. The titles utility contained in almost all low-cost editing applications make this very easy to achieve, with results that can appear as professional as those you see on TV each and every day. Apple's iMovie program even provides a titles effect that enables the creation of this very effect in a single menu selection, though if you know your way around picture-editing applications like Adobe Photoshop Elements or Paint Shop Pro, you will be able to create some equally impressive designs yourself.

Combining titles with transitions

Of course, you might not be content with a text that simply switches in and out. In fact, it is highly likely that you will prefer it to fade in and out over a background image – or even be given the luxury of a wipe or push-in transition. Whatever your preference, it is an easy matter to drop the appropriate transition onto the beginning and end of the title in exactly the same way that you will have done with your video clips. Transitions do not care what they are being applied to and will work in the same way regardless. In the more advanced editing programs in which a seemingly infinite number of additional video tracks are provided, it is possible to build up highly complex animated title sequences by stacking up layers of titles and then bringing them to life with transitions and effects.

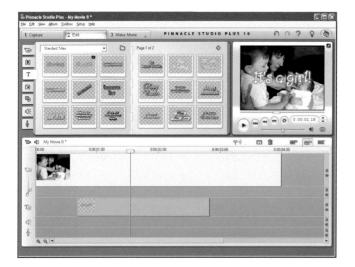

Ready-made title templates are provided with Studio Plus which can be dragged and dropped to the Titles track on the timeline. These can be modified.

Simple sound editing

Although it is easy to consider only pictures when discussing video recording and editing, sound is actually one half of the audio-visual experience and should therefore be given equal consideration. Here are a few sound editing tips to help you on your way to a perfect home movie.

Above: When recording a commentary, don't speak too closely into the microphone, and monitor what you're doing with headphones if possible.

Right: The audio waveform is represented by a sequence of sound waves which progress from left to right along a timeline, in this case that of the popular Audacity sound editing program.

Synchronous sound

When you press your camcorder's Record button to create a new clip, you record stereo sound as well as picture. It is often said that a viewer can tolerate average-quality pictures in a movie, providing the sound quality is good, but when presented with a movie in which the pictures are perfect at the expense of average sound quality, the viewer will quickly lose interest.

The camcorder generates a sound track that is synchronous with the picture, and this combination will remain right through to the point at which the clip is dropped onto the editing timeline; when you move the picture track, the twin (stereo) sound tracks will follow.

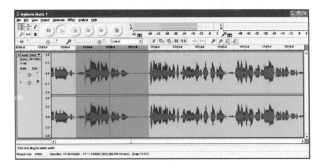

The audio waveform as your guide

Depending on the editing application you are using, you will have an option to view the clip's audio track in a number of ways. The best way to get a visual impression of what's going on, audio-wise, is to select the option that enables you to display the audio as a waveform. This will display as a fairly dense, though variable, sine wave throughout the clip. The more activity there is on the sound track – for example, loud speech or music close to the camcorder's microphone – the more intense the waveform's peaks and troughs will be. Where the recording level was very low, such as shooting in a silent environment, you will see very little activity on the waveform. You can modify the properties of the waveform to increase or decrease the sound level and to introduce fades and crossfades in the same way as you can with the video elements. In fact, it is likely that you will wish to include an audio crossfade to complement that on the video track.

Using rubber bands to adjust levels

The audio track's waveform may be accompanied by a horizontal line travelling through it, which represents the optimum audio level for the track – assume it to be the 100% position. Should you wish to moderate the level between any two given two points, such as when you wish to dip the level of music down behind the sound of somebody's speech, click on the point at which the fade is to start, then click to select (roughly) the point at which the fade ends, whereupon you can now drag the line down at the latter point. The sound will now fade in the way you have determined. Moving the points – called 'keyframes' – will change the properties accordingly.

watch out!

When manipulating digital audio levels manually, be careful not to raise them too high. If your program provides an onscreen sound level meter, do not let the sound level peak into the red as otherwise you will create distortion that will sound horrible when playing back.

Adding music and sound effects

When you reach the point where you are about to add music and sound effects to your edited video production, you know you are reaching a milestone – the point at which your movies are starting to look and sound professional.

Adding background music

The addition of music, either as part of a main introductory sequence or as a background accompaniment to sequences within your edited video production, is something you will wish to undertake fairly quickly, no doubt. In the same way that placing titles and credits onto your movie automatically raises the profile of the movie project, so music further enhances its effect on almost all audiences. However, like title fonts, it is important to use music wisely – the wrong music will destroy whatever effect you are seeking, so choose wisely.

Having done so, it is a relatively easy job to use a track on CD or stored as an MP3 track on your computer's hard disk. Music can be 'ripped' from CD either by Windows Media Player (on PCs) or within several applications like iMovie on an Apple Mac. Once stored in a local folder, it is an easy job to import it into the project and drop it onto the timeline, using the audio editing features that we have discussed previously to achieve the balance that suits you.

Using pre-installed sound effects

Apple iMovie is one example of several programs on Mac and PC that actually give you free use of lots of sound effects within the editing package, and it is a

must know

If you intend to copy music from a commercially-produced CD or a track that has been bought from an online store such as iTunes, be aware that you will be attempting to use music whose copyright is owned by a third party, and you should therefore ensure that you have obtained the necessary permission to use it first. The onus is on you to check before use.

simple job to select one from a list, preview it and apply it to the desired position on the appropriate track on the timeline. In the case of iMovie, it is also possible to pile multiple effects and other sound clips on top of each other – giving you the ideal opportunity to build up a complex and impressive 'soundscape' for your movie. Thanks to what is known as rubber-banding, you can also achieve the perfect balance between them all, as well.

Generating instant music tracks

Pinnacle Studio, among others, comes bundled with an excellent program called SmartSound, which consists of many music samples in a variety of styles and genres, making it very easy for you to determine the precise duration, in minutes and seconds, to which a piece of themed music should be applied. Once you have made your choice, simply tell the program to generate the music and it will be laid in exactly where required. Although the supplied samples will soon appear limited, it is possible to buy a vast range online using the links provided in the program.

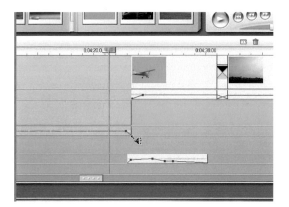

Making sure that a piece of music or a sound effect blends in with the rest of the sound on the timeline is easily achieved by manipulating the audio level control handles on each clip.

Converting analogue tapes

Most of us have lots of analogue videocassettes in addition to our digital tapes and disks, and it is reasonable to assume that there will be a need to bring them into the digital domain for safe-keeping. Here are some tips on digitizing and archiving.

must know

Use only S-Video connections if your original format is S-VHS or Hi8. These require component video processing, for which the S-Video cable is required, but standard VHS and Video8 recordings cannot use S-Video at all, and will often produce a black and white picture when copying.

Preserving analogue video digitally

There is little doubt that all but the youngest readers of this book will have plenty of analogue VHS and 8mm video recordings, either the large-format VHS tapes as recorded in home VCRs or one of the smaller formats as used in a range of analogue camcorders. It is possible that those who are familiar with earlier camcorder formats will have videocassettes in either VHS, S-VHS, VHS-C, Video8 and Hi8 formats, not to mention others that have been long forgotten. As we move rapidly towards an exclusively digital lifestyle it is not surprising that people want to copy their analogue recordings onto a digital format.

Using a DVD recorder

The simplest way to copy your old analogue recordings to digital is to connect the video and audio outputs of the source player (VHS player, analogue format camcorder, etc.) to the inputs of the DVD recorder. Having done so, it is a simple matter of setting the original tapes to Play and then pressing the appropriate buttons on the recorder. However, you will end up with MPEG2 files, and depending on the quality of your recorder's encoder and the compression settings selected, this may not be your best option even if it is the most convenient.

Copying to DV tape or computer

Another option is to use a camcorder that has the added ability to accept analogue ('AV') inputs and either re-record your analogue video assets to DV or Digital8 tape in the camcorder, or – better still – utilize a 'pass-through' capability, if it exists. This entails connecting to the camcorder as usual, but allowing the signal to pass through to the computer via a FireWire connection without first being re-recorded to DV tape.

Using standalone converters

As a result of large numbers of people now seeking to undertake this process, a wide range of dedicated hardware options now exist which facilite the conversion of video and audio signals from analogue to digital, with the result that a digital signal is fed to the host computer via FireWire. In some cases, these devices can process conversion in both directions – meaning that your edited project can be converted back to analogue for viewing on a TV or copying to VHS tape or similar.

If your camcorder will not allow you to copy analogue recordings directly into your computer, you will need a digitizer box. The S-Video cable is connected, along with the two audio plugs. The device converts the signals to digital and sends them to the computer via a FireWire output.

Copying cine films to digital video

Just as there are many people with analogue tapes that require transferring to digital, so there are also lots of old cine films looking for a new lease of life in the digital domain. Although it is best to get them copied professionally, it is possible to do the job yourself to a reasonable standard.

Getting the equipment together

If you decide to do the job of transferring your old 8mm or 16mm cine films to video yourself, you will need to ensure that you have the necessary equipment with which to tackle the task. First and foremost, you will need a projector on which to play the films. It is possible that if the films to be copied are yours, then you will probably have a projector. It is often the case that projectors have been stored away unused and unseen for several years, so check that the bulb is working and the parts are still in serviceable condition. If you are happy, then you can get set up.

Recording the projected image and sound

The simplest way to record films to video is to record the projected image with a camcorder. It isn't the perfect option, but it is better than nothing – and if you are careful you can produce reasonable results. Furthermore, if you have sound films you will need to find a way of connecting the audio output of the projector to either the mic input of the camcorder (if it has one) or to some other device that enables to record it separately from the pictures. The vast majority of of cine movies are silent, however.

The trick here is to project the film onto a bright and highly reflective card (glossy A4-sized inkjet paper is good for this) as small as possible in order to preserve maximum illumination. Focus the projector accurately by running a test sequence, and then set up the camcorder such that it is looking at the image as

squarely as possible. Let the camcorder's auto controls find the right setting, and then switch everything to manual. This is very important, since the film will go light and dark, and where there are white leader sections the camcorder's auto circuits will go crazy. Once you are happy with the results, record all of the films, pausing the camcorder during roll changes to help logging or indexing (if using a tapeless camcorder).

Coping with different film projector speeds

It is common for home cine films to have been exposed at a rate of either 16, 18 or 24 frames per second, none of which helps you to make a good transfer to video since none of them equate to the camcorder's scanning rate. Only 24fps comes close to the PAL frequency of 25fps, and even that will produce a moderate amount of strobing. If the projector has a variable speed option, try cranking it up to the fastest possible – that way the camcorder might cope with it better, and you should be able to compensate for the speed increase later when editing.

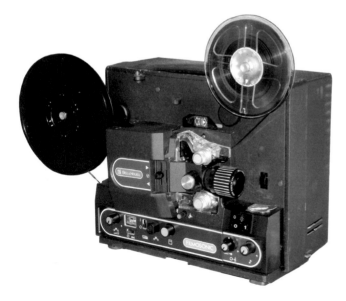

Although they are becoming harder to find, you will need an appropriate projector on which to load your cine films prior to recording the screen images with your camcorder.

Importing audio tapes and records

In addition to those old film and video recordings that require copying to digital, it is likely that you might have audio tracks on tape and vinyl that you would also like to digitize with a view to their inclusion in a video project. Here is how to do it.

Connecting up

To copy audio cassette tapes or vinyl records to your computer, you will need to check its audio outputs. In many cases, the two units are actually combined into a single music system that incorporates not only tape, but also a disc record player, AM/FM radio tuner and perhaps even a CD player. Alternatively, you might have a number of dedicated audio 'separates' – amplifier, tape deck, record turntable and so on – with which to cue and play back your chosen recording as it is sent to the computer for digitizing.

Make sure you clean your vinyl records carefully in order to remove unwanted surface crackle and pop, and be sure to set the pickup stylus to its optimum balance before commencing transfer.

Using a computer's sound input

If you are using an Apple Mac, you will be provided with a small jack input which is denoted by a tiny 'microphone' icon that can be used to accept the audio from the tape or record player. Owners of Windows PCs will very likely have minijack connectors on their computer's soundcard which will accept an audio input, in addition to the usual desktop speaker output.

If you have a standalone record playing deck, you will first need to feed the signal to an audio amplifier or music system, and then feed a line-level output to the computer's sound input. This is not necessary with a dedicated tape deck, however, whose output can be fed to the sound card or input. Furthermore,

it's likely that your audio hardware provides outputs video RCA Phono (red and white) sockets, so you will need to acquire a cable that connects these to a stereo minijack connector as is used by most sound input devices on home computers (Apple Mac included).

Capturing analogue recordings

With the computer now receiving the signal from the audio hardware, you now need to be able to capture and digitize it prior to it being saved as digital audio files on the computer. For this, you will need a program designed for the purpose. Whilst a little utility called 'Sound Recorder' is included with Windows, it is a very basic recorder which offers little control and is quite inadequate for the job. A much better alternative is an excellent audio capture and editing program called Audacity, which will do everything you need and more. The good news is that it is freely available – simply search Google for 'audacity' and you will find the download website. An excellent Apple Mac OSX alternative called Sound Studio is also freely available.

With your chosen audio capture program installed and ready for use, it is now a case of ensuring that the input levels have been properly established and that you are set up to make a good quality recording. Of course, make sure that you read the respective user-guides on the best way to do this. Having checked that you have everything properly recorded, you can trim the beginning and end of the track. On completion, save the captured track as a .WAV file (in Windows) or .AIFF (in Mac OSX), to a folder on your computer. From here, it can now be imported into your video editing program and used as an accompaniment to your edited video sequences.

want to know more?
- Several monthly magazines, such as *Digital Video*, *Digital Video Techniques* and *Videomaker*, include cover DVDs with each edition, each of which often contain free stock video footage which can be used to practice your editing skills.
- Join a camcorder or videomaker's group in order to pick up skills from experienced users

weblinks
- Check compatibility between DVD disc media, writer/re-writer drives and individual players at www.videohelp.com
- Download professional quality music for your productions from various sites, including www.yopo.co.uk
- Pick up some tips on digital video editing at www.mediacollege.com

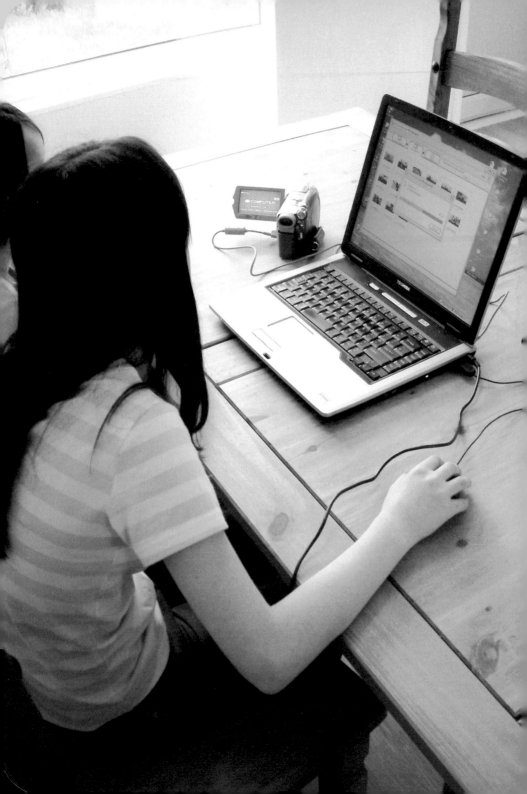

5 Showing and sharing movies

Having shot and edited your project, you are now in the position of having something to show off to members of your family, friends and perhaps even colleagues. Several options exist to enable you to show and share your movie project via tape, disk and the internet. In this final chapter, let's explore some possibilities to allow you to make the most of your home movies, whatever their themes.

Making a videotape

Despite the numerous exporting options that are now available to you as you complete your edited project, it is easy to overlook the convenience of using digital tape in the camcorder as a cheap and reliable means of backing-up your footage.

Making use of DV-inputs

If you shot your original footage on a DV format (such as MiniDV, Digital8, HDV), why not save the edited project back to tape as a secure master tape? Not only is it a cost-effective means of backing-up the edited project, but it is also very useful to have at your disposal a means of saving the material at its original quality. It does, of course, depend on your camcorder having a DV-input utility designed to enable it to accept a return feed from the computer via FireWire. Without it, you won't be able to re-record back to tape in the camcorder. If you are fortunate enough to benefit from this, however, it is a simple job to choose the appropriate export (or 'share') option in your editing program and leave it to get on with it.

Setting the camcorder mode

Before you can record an external signal into a DV-in enabled camcorder it is necessary to insert a new tape (or previously-recorded tape cued to the correct start point) and switch the camcorder to 'VCR' or 'Player' mode (depending on the make and model). Switching to Record mode, as many people assume it to be, is not the correct function, and nothing will happen. When a camcorder is connected via FireWire to your computer and in VCR mode, you will usually be able to see 'DV in'

text in its viewfinder and LCD screen. This signifies that it is capable of accepting an external digital input via FireWire (or i.Link, as it's also known). Once the cam is sitting in this mode and ready to accept a recording, you are ready to instruct your editing program to commence the 'Export to Tape' (or similar) process.

Final project rendering

Some applications, such as Pinnacle Studio, require a final render of the project timeline to be undertaken before it will commence the process of sending the edited movie out to tape in the camcorder. Depending on the number of transitions and effects employed in the project, this can take several minutes. Once done, it will automatically take over the control commands of the camcorder and commence re-recording without your intervention. There is no such delay with Apple's iMovie, however, since all the required rendering will have been performed at the time that the clips and effects were added to the timeline, so the 'layback' process will occur instantaneously.

Good housekeeping

You will invariably be presented with options to add a length of black screen before and after the recorded sequence. This is a good idea; it is not good practice to commence a layback right at the beginning of the tape, so instruct the program to record as much as 30 seconds black before the movie starts, and perhaps even 60 seconds or more afterwards. Tape is at its most unstable right at the beginning, and you do not want your master tape to be ruined once it is deleted from the computer. Placing black at the end of the project is also good in that the player screen won't go blank when viewing finishes.

To record your edited movie back to either MiniDV or Digital8 tape in your camcorder, connect up the FireWire cable and make sure that the camcorder is put into Play (or VCR) mode and not Record as you would assume.

Exporting options

You might decide that your edited projects will be viewed only on the computer screen or made available to one of an increasing number of digital home media systems which access the files on your computer. Several options are available to you.

must know

By compressing your edited video project to a format like MPEG-2 and then disposing of your original camcorder tapes, you will be stuck with the compressed quality of that format rather than the higher-quality digital tape format from which the project was derived. Consider the disposal or re-use of digital camcorder tapes carefully.

Media player application

Each of the two main computer operating platforms – Windows and Mac OS – offer their own default so-called 'media player' applications designed to provide a means by which you can not only view movies, but also play music tracks and even display photo slideshows. Both Windows Media Player and Apple Quicktime Player will do just this, not just on their respective operating systems but on others', too. Quicktime is universally available for use on Windows as well as Apple computers, with the reverse being also true of Media Player (although not as easily as with Windows). It is logical that you therefore decide to use export presets appropriate to each of these media player applications when selecting your movie export preferences for computer screen playback.

Exporting to portable players

With more and more people relying on the use of portable media players like the iPod and the PlayStation Portable, it is inevitable that the software companies will seek to provide export options appropriate for these formats. Certainly, the main video editing software companies were quick to respond to the changing preferences of users

wishing to share their edited projects with iPod Video and PSP users by adding ready-made, menu-selectable, export options – Pinnacle and Apple to name just two. Now, having completed your project edit, it is a quick and easy job to configure the export accordingly. Once the program has rendered and saved the file it is easy for you to move the file to the appropriate location – to your iTunes library, for instance – from where it can be exported to your portable media player and viewed whilst on the move. This is a great choice for people wishing to provide their own entertainment whilst on train, air or car journeys, of course.

Adding to a home media centre

In the same way that we can export movies to a portable player, so it is very easy to save our edited movie to a format and location from where it can be accessed by a so-called 'media centre'. This is

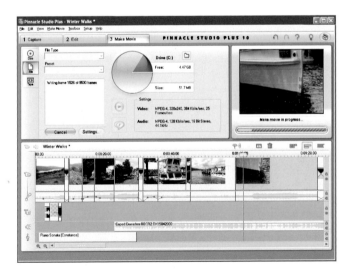

Pinnacle Studio Plus is a hugely popular Windows-based video editing and compression program that provides export options to a wide range of devices.

Pinnacle Studio provides export options to all the main player formats and even allows you to create files for portable media players, such as iPod and PSP (Playstation Portable).

usually a box which sits near to your video and audio playback devices (TV, home cinema set-up, audio system, etc.) and provides them all with outputs of digital movies, audio and even photo content which is stored on a computer's hard disk drive somewhere in your home or office. If a wireless network is in use, the unit will interface using a WiFi standard such as 802.11g, and provide seamless connectivity. In short, this means that you can save your media files to a shared computer folder to be read by the media centre and displayed on the appropriate device – video files on your TV, for instance, with full remote control.

To do this, you first need to export your video project to a format consistent will full-screen TV playback. This can be a full-specification AVI (Windows) or MOV (Mac) file in the appropriate screen ratio (4:3, 16:9 widescreen) and even 720p or 1080i line HDV if you are set up to play and display it. An alternative is to save as MPEG-2 or MPEG-4, both of which will save you hard disk drive space whilst minimizing perceived quality loss, or even another commonly used but highly compressed format called DivX, which is widely used to encode feature films as downloaded from the websites.

Storing your archive digitally

Thanks to the ever-decreasing cost and increasingly high capacity of hard disk drives, the use of secondary hard disks as the primary means of storage for your video library is now a practical and cost-effective option, and one that is preferred by many even to the saving of edited projects back to tape. Although the latter still offers a measure

of protection against sudden catastrophic failure of a single drive (with the subsequent loss of all media files if they aren't backed up), it is an option worth considering. Having digitized your whole collection of older recordings from VHS and 8mm camcorder tapes, it is very convenenient to be able to access them all from a single location using the computer's default media player software or home media centre interface. However large the disk capacity, it is a good idea to select a compression format that provides good quality whilst preserving disk space, and to this end MPEG-2 and MPEG-4 are good options.

As video compression and playback applications evolve, we're seeing increased opportunities for the storage, sorting, updating and sharing of all of our media assets in a single place, with the result that a single box can now do the job of several separate components.

watch out!

When setting up a wireless media file-sharing connection or network in your home, make sure you utilize all WiFi security options available to you or you might discover that somebody else is taking advantage of your assets and even stealing your computer-based information.

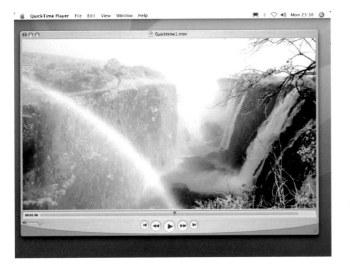

You don't have to be an Apple Mac user to take advantage of full MPEG-2 and MPEG-4 widescreen playback options in Quicktime Player.

Making DVDs and S-VCDs

The DVD has now established itself as the primary export and sharing medium for home movie-makers and, thanks to some extremely good, cost-effective, software it is something that a complete beginner can create with no prior knowledge.

Producing an instant DVD

With the exception, perhaps, of connecting your digital camcorder to a standalone DVD recorder and making a direct copy to disk – complete with thumbnails and chapter marks – perhaps the simplest way to produce a DVD copy of your home movie project is to use one of an expanding range of software options designed to enable complete beginners to make their first DVD with the minimum of experience or fuss.

Lots of companies offer such software at low cost, and there is also an increasing number of freely downloadable utilities on the internet, too, but it is also highly likely that you will be provided with such a utility in your recently-acquired computer.

One-click DVD authoring

Pinnacle's Instant DVD Recorder program is a perfect example of a software solution that makes it a snip to create a DVD copy of your camcorder tape. It should be borne in mind, however, that no editing whatsoever will take place when using this application to make your DVD; all that is needed is for you to load the tape into the camcorder, set it to Play (or VCR) mode and then use the application to cue the tape to the start point from where the DVD

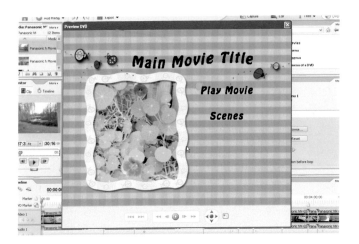

Intermediate editing and DVD creation programs like Adobe Premiere Elements provide many easy-to-use DVD menu templates, giving you pain-free interactivity at the press of a button.

copy will be made. Once you have told it to proceed, it will automatically make the DVD, complete with regularly-spaced chapter marks to aid navigation.

What you get is a DVD copy on which the DV or Digital8 data has been passed directly to the DVD writer drive via FireWire and encoded as MPEG-2 and which can be distributed to friends and family members very quickly. The DVD copy is made in little more than the time it takes for the tape to play in the camcorder – just like a dedicated set-top DVD recorder, in fact.

Template-based DVD authoring

If you are one of those people who has decided to explore the more creative aspects of DVD creation as a natural progression from editing your home movie footage, there are plenty of options designed to enable you to get started. Whether you are working on a PC or Apple Mac, it is possible for you to create highly interactive and impressive DVDs with the most basic software. Windows users can

As a leading video editing and authoring package aimed at beginners, Pinnacle Studio Plus 10 provides you with output templates to DVD, S-VCD and VCD disk formats.

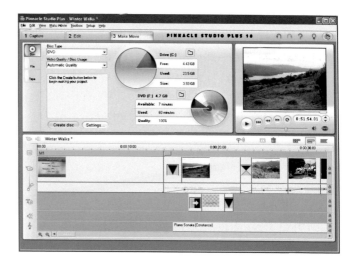

take advantage of the built-in menu creation and authoring interfaces within Pinnacle Studio Plus and Ulead VideoStudio, in addition to many other cheaply available options from other software companies. Apple Mac users don't have to look any further than the Applications folder of their computer's hard disk drive; iMovie and iDVD are made for precisely this task, and even beginners will have little problem getting a good job done extremely quickly.

These programs, along with many others, offer a wide range of template menu designs which you apply to the edited project timeline with a single click. In addition, these pre-formatted options will also provide you with the tools to add your own chapter marks and menu thumbnails, as well. In fact, there is so much that can be done with these entry-level options that many users never bother to move up to more sophisticated or professional level applications.

Linear versus non-linear

The most significant advantage of the DVD over traditional tape-based playback is its interactive capabilities. Tape playback is, by its very nature, a linear medium – whereas the ability to choose from a menu and skip from one place to another on a DVD in an instant makes its non-linearity very attractive indeed. This level of interactivity results from the setting of Chapter Marks – the reference points that are embedded into the master recording and to which the reader software jumps when the associated menu option is selected, or when the user clicks the 'next' or 'previous' key on the remote control.

Setting menu chapter marks

This is a process that is integral to most combined editing and authoring programs. Having first chosen to use a menu template that is consistent with the

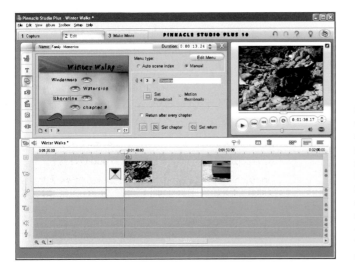

Having assembled your movie clips onto the timeline and selected a DVD menu template, Pinnacle Studio then helps you to create easy links between sections of the video and clickable menu thumbnail buttons on screen.

Although the screen interface itself varies between programs, Pinnacle's menu editor enables you to build your own DVD menus from templates or from your own imported background designs and clickable buttons.

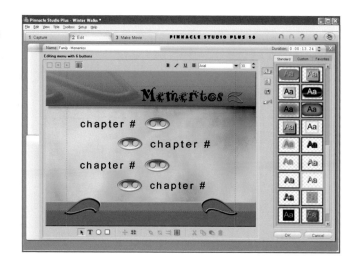

theme of your video project – a 'sports', 'birthday', 'vacation', and so on – you then need to set about deciding on where each section of your video will begin and end.

As the menu thumbnail will directly reference the position of the chapter mark, it is normal to set the chapter first. Usually this involves placing the timeline cursor at the appropriate point and clicking whichever function key relates to this process. Pinnacle Studio requires you to select the Create Menu Chapter button, which in turn places a little pink marker flag onto the timeline. This can now be named and, if necessary, moved. You will also have the opportunity to assign a specific frame from the sequence to act as a menu thumbnail which will appear on the screen when the user clicks the Menu button on their remote control. Different software packages facilitate this process in a variety of ways, so it's really important to take advantage of free, time-limited, software

trials on disk or via the internet before committing yourself to a particular program.

Testing the DVD

All mainstream DVD authoring programs provide an opportunity to test the functionality of the DVD authoring project in 'virtual' mode – that is, before it has actually been written to the disk. This is very useful, not only because it saves you the cost of a potentially useless disk (unless it is re-writable) but also because it enables you to make instant quick modifications to your work, such as tweaking the sound level at the beginning of a chapter or moving the mark itself. It is often the case that a minor problem will be discovered after you thought you had finished the job!

Saving a Disk Image

Sometimes you will want to go through the process of creating the DVD project in its entirety without actually burning to disk at that moment, or it could be that you are expecting to make more copies very soon. In this case, it is a good idea to create what is called a 'disk image' – writing to a location on your computer's hard disk instead of a blank DVD. At a later stage you can then ask the program (in fact, any software capable of reading and writing a disk image file, given that the components that make up a DVD video disk are standard) to write the disk image to a DVD. Most entry-level packages offer this useful facility as standard.

must know

An S-VCD disk is one that can accept MPEG-2 files that are similar to those used by DVD, with the exception that they have a lesser horizontal resolution – 480 pixels instead of 720 (in both NTSC and PAL) and as such are lesser quality. They can, however, be written to a regular CD disk.

If you are going to be making more copies to send to relatives and friends, then save your file to your computer's hard drive rather than to a DVD disk.

Compression of edited video files

As soon as we prepare an edited video project for sharing by disk, the web or portable media player, we are forced to look at ways of maintaining maximum quality whilst reducing the size of video and audio files as much as possible. Good compression helps to achieve this – so long as it is not overdone.

must know

The higher the bit rate value applied to video and audio compression, the more space it will require. So, you will get approximately 67 minutes of video on a standard DVD at 8,500 kbits/sec, but if you reduce this right down to 2,000 kbits/sec, you will squeeze as much as 270 minutes into the same space. At the expense of quality, of course.

Discarding data and gaining space

Although an edited video project will remain as either an AVI (PC) or MOV (Mac) filetype whilst it remains in its native form on the computer, it is necessary to modify it heavily if DVD, web movie or portable media playable outputs are required. The only way we can can squeeze an hour of DV-quality video and audio on to a standard-size, single-sided, 4.7GB capacity recordable DVD disk, for instance, is to carry out some very heavy number-crunching. That is not to say that we need to use our calculators, but we need to make use of software and systems that will literally compress our native files down to a size where it can be accommodated in a significantly smaller space. For this, we need to apply some form of compression which will reduce file sizes whilst maintaining quality; the data needs to be compressed at the production end and decompressed at the user's end without, hopefully, the viewer noticing the difference. That requires a CODEC (COmpressor – DECompressor) to do the hard work.

Compressing for DVD

There are lots of video-related CODECs in common use, but by far the most common is MPEG, and in

particular MPEG-2. This is the international standard compression format for all DVD video disks of the sort that we use in our homes. MPEG-2 is used to take a standard DV-stream file (such as that captured from DV or Digital8 tape) and apply very heavy compression of picture and sound without noticeable loss. Thus, a 60 minute DV-AVI file can, for instance, be reduced from 13GB to approximately 2.75GB when applying an average bit rate of 6,000 kbits/sec and accompanied by a 16-bit, 48kHz stereo audio track at 224 kbits/sec. The majority of domestic DVD players can handle a bitrate of just above 8,000 kbits/sec, and the higher the bitrate the better the perceived quality, in general.

Compression for other options

Other compression systems are appropriate to the intended display and distribution options; Windows Media Format video and audio compression can be applied in a wide variety of settings to files intended for playback on the computer screen, on the web or even on portable media players. As a guide, the same 60 minute DV-AVI file compressed to a full-sized file in Windows Media Format at 'High-Q' setting, 1943 kbits/sec with 16-bit stereo Windows Media Audio at 48 kHz, will consume approximately 75MB of disk space, depending on the TV/video standard and the recording quality. Both WMF and Quicktime (Apple's proprietary media player, compression and conversion program that is available for both systems) can be used effectively to reduce files to a format that is fully compatible with the internet and email. All these systems are easy to familiarize yourself with quite quickly.

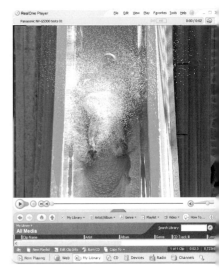

Real Player is another popular desktop video player utility that will allow to play movies you've edited, in addition to those streamed from the internet. It will also make it easy to burn files to DVD and portable players.

Alternative distribution presets

Lots of applications now provide drop-down presets
for export of video files for use with Apple iPod Video
and Sony PSP, both of which utilize the newer, more
heavily-compressed, MPEG-4 CODEC; select one of
these and all the required audio and video settings
will be selected automatically. This is also the case
with DivX – a format very popular for its high
compression in addition to high quality, and is
favoured by many who like to share feature-length
video files over the internet.

Movies and the Internet

Preparing an edited movie file for sharing via the
internet has never been easier. The wide range of
presets offered by all Windows and Mac editing
programs have taken the guesswork that previously
frustrated the efforts of many video-makers, which
has also made it much easier to experiment with the
most appropriate setting for your footage.

What has also driven the need to share via the
internet has, of course, been the speed and quality of
broadband internet connections. With a high
percentage of web users now accessing the internet
via broadband connections, the requirement to
make critical judgements about the CODECs used
has largely been removed. Today, the creation of
large volume files at higher bitrates than ever before
is common, thanks to the speed at which people can
download or stream their playback.

Download or streaming media

Internet movie files, when uploaded to a web server
(such as that used to host your family, school or

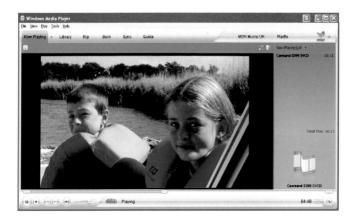

Windows Media Player is one of a handful of desktop media player applications to which your finished files can be exported.

workplace website), can now be accessed and played reliably without any complicated preparation. However, you may have noticed that some movies require downloading to your computer in their entirety before being played, whereas others will start to play almost immediately. This is because those movies that play straight away are said to be 'streaming', whereas others are referred to as 'download' movies.

Movies that stream usually have to be prepared in a particular way (such as when encoding using the basic settings in Quicktime), though movies that are encoded using Windows Media Format generally have no such requirement and are configured to play almost immediately. It is worth researching this area a bit more if you are keen to publish your movies on a website – better still to experiment with different software and different settings yourself!

It's a topic that can get very complicated very quickly, so while you're at the beginner's stage, it's a good idea simply to use the supplied compression presets that are built in to the applications.

Sharing your movies on the web

You don't need to know how to build websites in order to share your edited movies on the web, as there is a choice of online utilities that make it a quick and painless process. Let's see what is available.

must know

Remember that if you are uploading your clips to your own webspace you must be careful not to exceed any limits that your internet service provider has placed on the amount of data that you can download in a given month. Movie clips use a lot of bandwidth, and any excess will either be capped or charged.

Preparing to share

What these utilities are designed to do is to take the guesswork and hassle out of making your movies available for all to enjoy on the web. To that end, you will first need to have edited and compressed your project to a web-ready format (see pp180-3).

Hosting options

There is a range of very user-friendly applications available for use online right now. Among them are Mydeo, Neptune and Apple's .Mac. All of them offer the means for you to transfer your chosen movie file from your computer to the remote server (the system

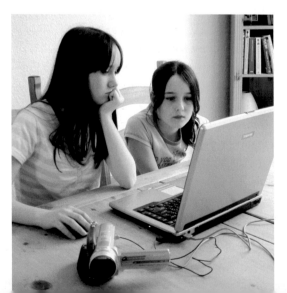

Connect your camcorder to your computer and, thanks to the internet, you'll be able to send copies of your movies to friends and relatives anywhere in the world within minutes.

from which they are made available on the web). Once that is done, all you then have to do is to complete some basic information about the movie and tell everybody where it is. Some systems even include an 'email your friends' option.

It is a good idea to check out the websites of any streaming facility you find, since they each have their requirements and foibles. Apple's .Mac (iDisk) account, for instance, favours Quicktime whereas Mydeo requires WMV, where you will also pay per minute for material hosted. Viewing is free, however.

Uploading to your webspace

If you have your own website with sufficient webspace to accommodate movie clips, why not upload your web-ready clips and make them available to others? It is very easy to do, though having a broadband internet connection will help when it comes to sending the large files to the remote web server.

If you use a piece of software called an FTP client on your computer, use this to connect with the relevant folder on the server and then drag and drop the compressed video files accordingly.

Once your file is uploaded, it is easily accessible by opening your web browser, such as Internet Explorer, Mozilla Firefox or Apple Safari, and typing the precise file path to the clip (that is, the exact web address that includes not only your domain name, but the folder in which the clip is stored, followed by the filename). Don't forget the file extension, either; this will be .wmv for a Windows Media Format file or a .MOV for an Apple Quicktime movie. When you have done so, the computer will open the appropriate media player for the file and you will then be able to view it.

want to know more?
- Pick up a popular magazine on Digital Video and install one of the many trial programs that are included on cover disks.
- Experiment with the software that comes on the disk accompanying your camcorder as a means to get started.
- Check out online bookstores for more information on how to learn more about the craft of video editing and authoring.

weblinks
- Visit Ulead's website for video editing and authoring programs at www.ulead.com
- Visit Pinnacle for trial downloads of Studio Plus at www.pinnaclesys.com
- Visit Adobe's website for trial downloads of Premiere Elements and Photoshop Elements at www.adobe.com

Glossary

AIFF Audio Interchange File Format, the native audio format on Apple Macintosh computers.

AVI Audio Video Interleaved. A Microsoft media file format for use within Windows, and the default file format for captured video files on Windows-based systems due to its high quality compression.

CCD Charge Coupled Device converts the picture elements into an electrical charge which is proportional to each pixel's colour (chrominance) and saturation (luminance).

CODEC Short for COmpression and DECompression, as used to compress a lot of data into a small space (such as video and audio), and then decompress it at the playback stage.

DiVX An alternative to the standard MPEG-2 DVD format, DIVX achieves a similar level of playback quality despite a higher level of compression.

DVD Digital Versatile Disk. High capacity development of the Compact Disk.

FireWire A digital connection between DV and Digital8 camcorders, computers and other peripherals like hard disk drives. Also known on some makes of camcorder and computer as 'i.Link', but properly referred to as the IEEE1394 standard.

font Style of lettering, or typeface, as applied to titles and captions.

f-stop A measurement of the aperture, or opening, of a lens and measured in f-numbers. Each f-stop represents a doubling of the amount of light entering the lens over the preceding higher number.

HDD The hard disk drive is used as the primary storage medium on a computer and for movie files in HDD camcorders.

Hi8 Variant of Video8 analog videocassette recording system that is fast becoming obsolete. Uses S-Video (Y/C component) signal processing to reduce visual noise.

JPEG Abbreviation for the Joint Picture Experts Group. An industry group which defines the compression standards for bitmapped colour images.

LCD Liquid Crystal Display. Colour display commonly used in flip-out screens on camcorders. Also used in some viewfinders.

MOV The file extension applied to Quicktime media files. The default video capture file format as used by Apple Mac-based video

capture and editing applications.

MP3 Type 3 CODEC used to compress audio files into a form that is downloadable from websites and can be stored in portable devices.

MPEG Motion Picture Expert Group, responsible for the MPEG-1, MPEG-2, MP3 and MPEG-4 compression formats as used in digital audio-visual media.

RGB Red, Green, Blue. The three primary colours of light.

S-VCD Super Video Compact Disk. Uses MPEG-2 encoding to store and replay media files at a resolution of 480x576 (PAL) and 480x480 (NTSC) on a standard CD for playback on DVD players of computer-based media players.

S-VHS Super Video Home System. Variant of VHS which uses higher bandwidth and Y/C component signal processing to reduce noise inherent with standard VHS systems.

S-Video A process of transferring and recording standard composite video in which the chrominance (colour) and luminance (saturation) are handled separately to reduce picture noise. Used by Hi-8 and S-VHS format devices.

timeline The visualization of a video or film project in time as represented by a horizontal workspace contained within the screen interface onto which clips are assembled.

transition The means by which the viewer is transported from one part of the story to another using a wide range of visual tools, such as dissolves, wipes and 3D variants.

upload Process of transferring data from a personal or network computer to a remote computer, such as an internet server.

USB Universal Serial Bus. A port (socket) on most modern computers for the connection of peripheral devices to an Apple Mac or Windows PC.

VCD Video Compact Disk. Uses MPEG-1 encoding to store and replay media files at a resolution of 352x288 (PAL) and 352x240 (NTSC) on a standard CD for playback on DVD or computer-based media players.

Video-8 Analog format developed by Sony and fast becoming obsolete. Uses 8mm wide videotape cassettes.

WAV Derived from 'waveform'. The native audio file format as used by Windows-based computer systems.

Y/C Component A type of video signal connection in which the colour and luminance elements are processed separately for improved visual quality. Used with Hi-8 and S-VHS.

Need to know more?

The best sources of information and advice about digital video are undoubtedly books like this, monthly magazines and, of course, the internet. In fact, the increased use of broadband internet means that there is now a wealth of interactive multimedia content to assist you on your learning curve. Here is just a small sample of what is available.

Useful websites

www.adamwilt.com
This US video system engineer's website is a treasure trove for all manner of technical info.
www.adobe.com
The company whose digital video and imaging software products occupy a dominant position.
www.apple.com
Information on Apple hardware and software; downloads and much more.
www.bbc.co.uk/videonation/filmingskills/
Highly acclaimed BBC 'how-to' site dedicated to guiding would-be makers of Video Diaries for television, but containing tons of good, basic digital video-making advice for all beginners.
www.bbctraining.com/onlineCourses.asp
Providing free online courses ranging from Basic Principles of Shooting to Lighting and Sound guides.
www.dv.com
The online resource of DV magazine – a great site dedicated to all things DV, with excellent forums and a monthly magazine.
http://desktopvideo.about.com
This extensive resource provides in-depth information, reviews, starter guides and special

offers on a range of hardware and software systems for DV makers.
www.microsoft.com
Not just for downloads and updates of the company's leading Windows operating system software, but where you can download Movie Maker editing software for free, too!
www.papajohn.org
The definitive source of information on how to make the best use of Microsoft's Movie Maker video editing software anywhere on the web.
www.pinnaclesys.com
Pinnacle's website is where you can buy editing software such as Studio and Studio Plus, in addition to digital home media systems.
www.simplydv.co.uk
The author himself brings you the no-nonsense guide to choosing and using digital video hardware and software.
www.ulead.com
The company which brings you the hugely popular VideoStudio, DVD Movie Factory and DVD Workshop digital video applications.
www.videohelp.com
Excellent site dedicated to everything connected with the making of VCD, S-VCD and

DVD content. Contains in-depth reviews and comparisons of hardware and software.
www.videoguys.com/started.html
Leading digital video editing and production experts website has an excellent starter guide.
www.videomaker.com
The complementary website to the USA-published *Videomaker* magazine.
www.wrigleyvideo.com
Tutorials section containing free, full-motion video tutorials on Adobe's Premiere Pro, Encore and Audition digital video products.

Want to learn more?

In every country there is a growing number of camcorder user and digital video-making groups and clubs who are always looking to expand their membership of beginners and experienced users alike. It is a great way to pick up new techniques and develop skills, so look in your local media or directories for contact information. There is an increasing number of Continuing Education opportunities, as well, with day and evening courses often available.

Further reading

Ang, Tom *Digital Video Handbook* (Dorling Kindersley, 2005)

Barrett, Colin *Digital Video for Beginners* (Ilex, 2005)

Brandon, Bob *The Complete Digital Video Guide: A Step-by-Step Handbook for Making Great Home Movies Using Your Digital Camcorder* (Reader's Digest, 2005)

Buechler, John *Windows MovieMaker 2: Do Amazing Things* (Microsoft, 2003)

Gaskell, Ed *The Complete Guide to Digital Video* (Ilex, 2003)

Harter, Andrew Mayne *How To Make and Action Movie for $99: A Guide to Writing, Shooting and Editing a Feature Film in the Digital Age* (Maynestream, 2005)

Hull, Robert and Ewbank, Jamie *500 Digital Video Hints, Tips and Techniques: The Easy, All-in-one Guide to Those Inside Secrets for Better Digital Video* (Rotovision, 2006)

Johnson, Dave et all. *How To Do Everything With Your Digital Camcorder* (Osborne McGraw-Hill, 2003)

Kiryanov, D. *Digital Moviemaking with Pinnacle Studio Plus 10* (A-List, 2005)

MacRae, Kyle *The Digital Video Manual: A Practical Introduction to Making Professional-looking Home Movies* (Haynes, 2005)

Sengstack, Jeff *Sams Teach Yourself Digital Video and DVDs All in One* (Sams Teach Yourself, 2005)

Strayer, Pam *Create Your Own Digital Movies: Using What You Already Know* (Sams, 2005)

Towse, Mark *The Complete Guide to Digital Video* (Sanctuary, 2002)

Underdahl *Digital Video for Dummies* (Hungry Minds, 2003)

Various *Videomaker Guide to Digital Video and DVD Production* (Focal, 2004)

Wells, Peter *A Beginner's Guide to Digital Video* (Ava, 2004)

Wells, Peter *Digital Camcorder Techniques* (Crowood, 2006)

Index

Accessories 32-3, 88-9
 external microphones
 88-9, 110-13
 monopods 88
 portable lighting 89
 tripods 88
Analogue 10, 11, 12, 15, 19,
 20, 35, 41
Apple Mac 13, 28-9, 33, 42,
 122, 123, 124, 125, 126,
 128, 129, 132, 133, 135,
 158, 164, 165

Betamax 10
Bits and bytes 10-11, 12

Camcorders 32-3
 accessories 32-3, 88-9
 built-in effects 66-7
 tapeless 44-7
CCD (Charge Coupled Device)
 13, 19, 20, 23
Chroma-key 148-51
Cine films 162-3
Clips 134-5, 136-7
Close-ups 76-81
CODEC 180, 182
Commentary 112-3
Compression 180-3
Computers 28-9, 42, 123-4,
 128-9
Connections 13, 19, 28, 29,
 33, 35, 38-9, 40, 41
Converting tapes 160-1
Copying 40-1

Digital
 effects 42-4, 66
 recording formats 14-17
 tape 44, 48, 168-9
 Video index
 what is 10-13
 zooms 22
Digital8 14, 15, 16, 18, 22, 27,
 28, 29, 32, 34, 35, 115,
 124, 125, 128, 129, 130,
 132, 133, 161
DVD 9, 10, 14, 15, 16, 17, 18, 22,
 24, 25, 26, 27, 28, 29, 33,
 37, 40, 44, 45, 46, 49, 64,
 67, 123, 125, 130, 131, 132,
 133, 136, 160, 165, 174-9,
 180, 181

Editing 70-3, 120-65
 in camera 70-1
 planning for 72-3
 video 122-5
 your movies 24
Effects and filters 144-7
Email or web-cam movies 25
Exporting option 170-3

Features and functions 20-3,
 34-5
Filming
 children 90-1
 holiday movies 92-5
 personal memories 104-7
 sports or special events
 96-9

weddings 100-3
FireWire 13, 17, 19, 22, 24, 28,
 29, 32, 35, 40, 122, 124,
 125, 126, 128, 129, 131,
 133, 161

Hard disk drives (HDD) 12, 14,
 16-17, 22, 26, 27, 29, 40,
 46
Hi8 12, 15, 19, 41, 160
High definition 126-7

i.Link 13, 22, 24, 29, 169
Importing 130-3, 164-5
 audio tapes and records
 164-5
 cards and disks 130-3
Improving techniques 50-3

Light 60-3, 82-3

Manual controls 58-9
Megapixels 23
Menu 54-7
MicroDrives 12, 14, 16-17
Microphones 108-13
MMC (MultiMedia Cards)
 13, 17
Movement 84-7
MPEG 14, 16, 17, 25, 27, 46,
 47, 115, 126, 132-3, 160,
 170, 172, 173, 175, 179,
 180
Music and sound effects
 158-9

Panning 80–81, 86, 98
Picture-in-picture 148–51

Recording 25, 26–7, 34, 36–7,
 38, 40, 41, 42, 44, 45, 46,
 47, 48, 49, 50, 52, 55, 57,
 60, 61, 64, 65, 66
 formats 14–17, 33
 media 48–9

SCART 39
SD (Secure Digital) 13, 14, 16,
 17, 22, 27, 29, 35, 46
SD-Video cardcams 17, 27
Sequences 138–9
Setting the scene 74–5
Sharing movies 24, 28, 184–5

on the web 184–5
Sound editing 156–7
Sound recording 108–13
Standard definition 126
Stills 13–14, 35, 47, 114–5
S-VCD 179
S-Video 41

Temperature control 60–3
Timecode 64–5
Timeline 136–7
Titles 22, 42, 152–5
Tripod 84, 87, 88
TV, viewing movies on 38–9

USB 13, 22, 25, 29, 32, 33, 40,
 47, 124, 125, 129, 131

VHS video players 10
Video transitions 140–3
Video8 10, 15, 19, 160

Widescreen 23, 116–9
Windows PC 13, 28–9, 42,
 123, 125, 128, 129,133,
 164

Zoom microphones 22
Zooming 78–80, 86, 97

Acknowledgements

All images copyright Colin Barrett, except Apple Computer Inc. (page 123), Andrew Ball
(pages 81, 87, 183), Ben Bruges (pages 50, 98), Brian Chalke (pages 94, 173), Jupiter
Images/Photos.com (pages 19, 52, 74, 75, 92, 93, 105), JVC UK Ltd (pages 12, 45), Paul
MacBeath (pages 51, 146), Panasonic UK Ltd (pages 17, 27, 47), Russell Potts (pages 97,
181), Sony UK Ltd (page 13), Brian Taylor (pages 79, 80, 86, 114, 117, 118, 127), Michael
Weight (page 85). Used by permission. All rights acknowledged.

The author would like to thank Jodie-Ann Langley, Amber Lawrence and Dylan
Lawrence for their eagerness to pose in front of the camera and their mum Kim for
arranging things; to Ewan and Alana MacBeath for their starring roles as usual, to their
parents Paul and Natalie MacBeath, my son Greg, my parents, Colin (Snr) and Sonia
Barrett, for keeping the ship afloat whilst writing was in progress, and – not least – to
my ever-patient and understanding wife Sylvia for being there, as always.

⚙ **Collins** need to know?

Look out for these recent titles in Collins' practical and accessible need to know? series.

Other titles in the series:

Antique Marks
Aquarium Fish
Birdwatching
Body Language
Buying Property in France
Buying Property in Spain
Card Games
Chess
Children's Parties
Codes & Ciphers
Decorating

Digital Photography
DIY
Dog Training
Drawing & Sketching
Dreams
Golf
Guitar
How to Lose Weight
Kama Sutra
Kings and Queens
Knots

Low GI/GL Diet
Pilates
Poker
Pregnancy
Property
Speak French
Speak Italian
Speak Spanish
Stargazing
Watercolour
Weddings

Wine
Woodworking
The World
Yoga
Zodiac Types

**To order any of these titles, please telephone 0870 787 1732 quoting reference 263H.
For further information about all Collins books, visit our website: www.collins.co.uk**

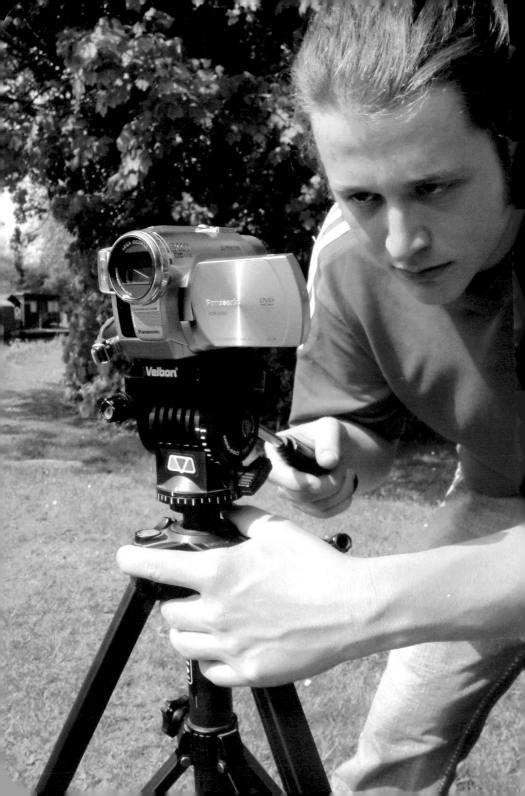

Collins